The Language of Flowers

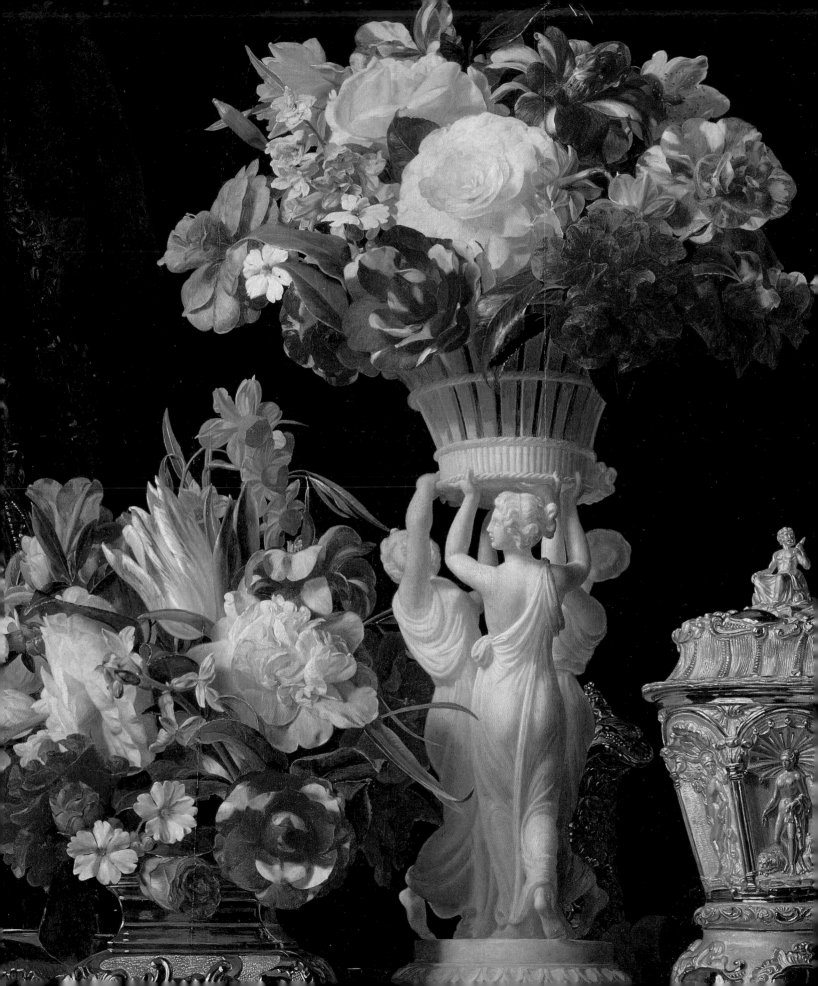

Marina Heilmeyer

The Language of Flowers

Symbols and Myths

Prestel

Munich · Berlin · London · New York

© Prestel Verlag, Munich · Berlin · London · New York,
2006
(Revised edition; first published in 2001)

Text contributions by Susanne Weiss

Translated from the German by Stephen Telfer, Edinburgh
Edited by Christopher Wynne, Munich

Cover: detail from Jan van Huysum, *Bouquet of Flowers in front
of a Park Landscape*, *c.* 1730 (see page 73)
Frontispiece: Ferdinand Waldmüller, *Birthday Table*, 1840
(see page 25)

The Deutsche Bibliothek holds a record for this publication
in the Deutsche Nationalbibliografie; detailed bibliographi-
cal data can be found under http://dnb.ddb.de

Library of Congress Control Number: 2005910487

Prestel Verlag
Königinstr. 9, 80539 Munich
Tel.: +49 (89) 38 17 09-0
Fax: +49 (89) 38 17 09-35

Prestel Publishing Ltd
4 Bloomsbury Place, London WC1A 2QA
Tel.: +44 (20) 7323-5004
Fax: +44 (20) 7636-8004;

Prestel Publishing
900 Broadway, Suite 603, New York, NY 10003
Tel.: +1 (212) 995-2720
Fax: +1 (212) 995-2723
www.prestel.com

Design and layout: Maja Kluy, Berlin
Cover design and production: Andrea Mogwitz, Munich
Origination: LVD GmbH, Berlin
Printing and binding: Print Consult, Munich

Printed in Slovakia on acid-free paper

ISBN 3-7913-3570-7

The Flowers

Marina Heilmeyer

Introduction

A look at the centuries-old relationship
between flowers and their admirers

*"Oh, Tiger-lily", said Alice, addressing herself
to one that was gracefully waving about in the wind,
"I wish you could talk!"
"We can talk", said the Tiger-lily,
"when there's anybody worth talking to."*

When, in 1872, Lewis Carroll sent Alice through the looking glass into the garden of talking flowers, the debate surrounding the soul and the language of flowers had already begun to wane. Started in Europe towards the end of the eighteenth century by Jean-Jacques Rousseau, the debate was prompted by the 1761 publication of his novel *Julie, ou la Nouvelle Héloïse* (Julie, or the new Eloise). "Feeling" as a spiritual dimension had been rediscovered; a lively appreciation of the beauty in nature was to instil morality and piety in people. The question first asked by Aristotle as to whether plants had a soul or not, was duly rekindled. He had drafted a hierarchy of living things which placed plants between inanimate nature and animals, attributing them with their own specific type of soul, despite their inability to move.

Judging by early written documents, considerable time and thought has been devoted to plants, their qualities and the effects they can induce. Very early in history and under difficult circumstances, a surprising wealth of information was gathered as to the use of different plants and their beneficial or detrimental effects on the mind and body. From here, it was only a short step to divine powers being seen at work in flowers, powers that—through the plants themselves—influenced human lives.

The ancient Egyptians believed that divine power was contained within the scent of a flower. On their frescoes, figures are frequently portrayed enjoying the delicious fragrance of blue water lilies. By breathing in the scent, they believed that they were inhaling divine power (fig. 1).

Plants had a very particular symbolic importance in Egypt, being a hot and sandy country that afforded little shade. They flowered beside artificial ponds in the gardens of the wealthy and in temple complexes; bound together to form garlands and wreaths, they decorated banquet tables and were worn by the guests; and, as

bouquets and garlands, they accompanied the dead on their journey into the hereafter. The Egyptians' profound love of gardens and flowers is expressed in the poetry of the ancient kingdom. Their many love songs, like the Hebrews' *Song of Songs*, contain numerous floral allusions and comparisons. When the Romans, under Julius Caesar, conquered the land of the Nile, philosophers arrived with them, too. In their writings they describe the overpowering fragrance of the flowers they discovered throughout the country and express their fear that the heady scents could obscure their mind and impair their judgement.

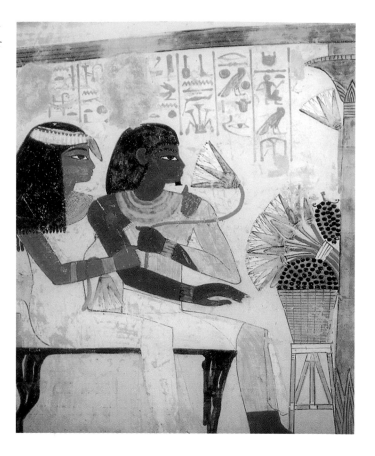

The ancient Greeks also had a love of flowers, garlands of aromatic herbs and sprigs interwoven with colourful blooms. Mythological figures and stories were used in an attempt to explain the beauty of flowers, the changing seasons and nature's ever-recurring cycle. Different plants were associated with individual gods and their origins were sometimes explained by tales of humans being transformed into plants themselves. Like the stories in the Bible, these ancient myths were, over the centuries, considered another inexhaustible source brimming with allegorical interpretations of nature. At the same time, the Greeks made an early attempt at recording the plant world systematically and describing their finds. Most of today's botanical names, however, appear in a Latinized form, although only a limited number of them can trace their roots back to the descriptions given to them by the Romans.

Very little is known about ancient Greek flower gardens, even though commercial nurseries must have existed since the sixth century BC by which time the custom of wearing garlands had gained considerable popularity. Religious rites were performed by celebrants wearing floral decorations; sacrificial animals had wreaths placed around their necks; special events were highlighted using carefully selected flowers and greenery and, at those banquets which adhered to certain rituals, the guests always wore garlands. The flowers and leaves used were an indication of the type of occasion. Myrtle wreaths or olive leaves were associated with military triumphs or political functions; wreaths of laurel, olive and celery signified success in sport; artists and poets were presented laurel wreaths; and rose, hyacinth, violet and lotus flowers were worn by guests at banquets, as reflected in the poet Sappho's highly poetic description around 600 BC of a young girl's ornamentation: "Many sprigs of violet, rose and crocus have I entwined in your hair."

Fragrant flowers were planted as a source of pleasure in gardens and placed on graves where the scent was regarded as a sign of the transfiguration of the deceased.

fig. 1 Nacht's grave in western Thebes,
18th dynasty, *c.* 1400 BC.
Nacht and his wife Taui admiring a blue lotus,
Nymphaea coerulea. Detail from the right-hand
rear (western) wall.

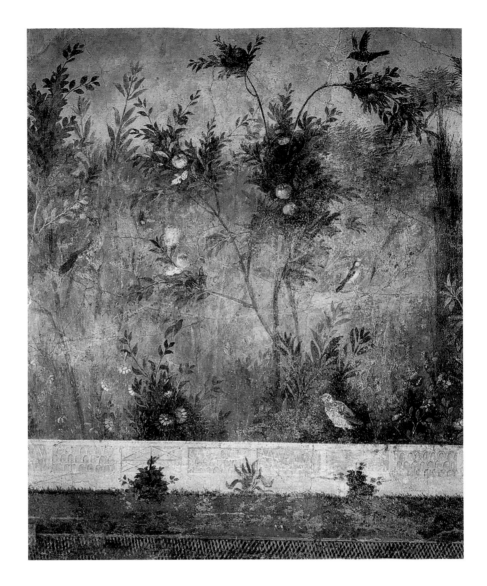

"Violet-crowned" Aphrodite, the goddess of love and beauty, was the protectress of flowers and gardens.

In Greece during the second century BC, a literary genre arose whose influence was felt throughout the centuries, particularly in the Middle Ages and the Renaissance—and to a lesser extent—even in modern times. It took love as its central theme, set in magnificent gardens and pastoral landscapes amid unspoilt natural surroundings. A wealth of genre paintings was created at the same time, too. However, the oldest pictures of gardens to have survived are Roman (fig. 2).

The goddess Flora, the protectress of gardens, is one of the oldest figures in the Roman pantheon. The *Floralia* festival, held in her honour between 28 April and 3 May, was a lively, indeed licentious, spring festival that celebrated the fertility of all things. This custom was revived in Renaissance Florence. The notion of humans being transformed into plants is found in Greek explanations of the world and was

fig. 2 Fresco from the peristyle garden in the villa of the empress Livia at Primaporta, Rome, *c.* 20 BC

· 9 ·

taken up by the Roman poet Ovid in the first century BC. His *Metamorphoses* greatly influenced Renaissance and Baroque literature and art.

The citizens of imperial Rome made extravagant use of flowers. They "carpeted" whole rooms with rose petals or fragrant saffron crocuses. Following the fall of the Roman Empire around 550, however, this refined type of floral art disappeared from Europe for several centuries because the early Christians regarded flowers and paintings with great suspicion, seeing in them symbols of a "decadent" pagan culture.

The rejection of flowers as decoration and as subjects for paintings led to the decline of floriculture and horticulture in the western world. The ancient world's knowledge survived only in libraries and in monastic gardens where useful and medicinal plants were cultivated. Attitudes to the plant world did not change until Charlemagne was crowned Holy Roman Emperor in the year 800. It was while on crusades in Moorish Spain that he became acquainted with Arabic gardens in which flowers had their own very special meanings. The rose, for instance, was said to have sprung from a drop of sweat from Mohammed's eyebrow during the Night Journey. As in later Christian symbolism, the beauty of each flower in Islam is a symbol of God's spirit. To a devout Muslim, a garden on earth heralded a heavenly paradise (fig. 3).

Around the year 800, Charlemagne, in his *Capitulare de villis vel urbis*, commanded that a basic stock of medicinal plants as well as fruit and vegetables should be grown in the gardens of his castles and farms and, in so doing, created the foundations of European horticulture. His friendly relations with Harun ar-Rashid (763/766–809, idealized as the caliph of *Thousand and One Nights*) can be traced to some rare Oriental plants. At around the same time, the abbot Walahfried Strabo established a garden at the Benedictine monastery on the island of Reichenau on Lake Constance, Germany. He wrote about the flowers growing there: "Two flowers so well-loved and admired, that over the ages have stood as symbols of the greatest treasures of the Church, which has plucked the rose as a symbol of the spilt blood of the martyrs and which wears the lily as a shining symbol of faith; pluck the rose for war, the smiling lily for peace."

The spell had now been broken and the culture of flowers, the symbolism of flowers and the language of flowers developed in quick succession.

Much material from antiquity was picked up again and reinterpreted to suit Christian beliefs. Elements of Platonic thinking intermingled with Roman, Christian and Teutonic ideas, and all of them influenced human attitudes to plants.

fig. 3 *Mohammed's Rose* from the *Akhlaq-i Rasul Allah* manuscript, Turkey, 1708, Dept. of Oriental Art, Staatsbibliothek Preussischer Kulturbesitz, Berlin

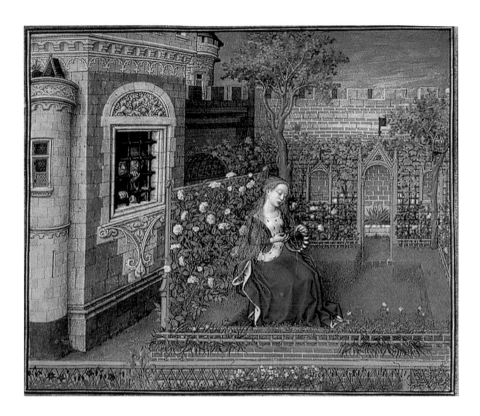

Monastic gardens were proclaimed earthly paradises. For the pleasure they gave, flowers were permitted alongside medicinal plants. The beauty of nature was seen as proof that God had created the world.

Guillaume de Lorris's *Romance of the Rose* appeared in France in the first half of the thirteenth century. He created the romance genre of the Middle Ages and chose a garden as the setting for his dreamy tales in which flowers become the messengers of feelings. Intimacies were exchanged in a figurative, roundabout way and every educated person understood the symbolism of the gift of a posy. The original version of *Parsifal* tells the tale of the imprisoned Oriane who is unable to write or speak to her beloved. He, however, succeeds in throwing her a tear-stained rose as a symbol of his love and pain.

"I have come to my garden, my sister and bride," declares Solomon in his *Song of Songs*. This probably gave rise to the *hortus conclusus* of the Middle Ages, a small paradise on earth (fig. 4). During the era of the minnesingers, it became a garden of love where floral garlands were bound and exchanged. "Take this wreath, lady, and grace the dance," wrote Walther von der Vogelweide, the great German lyric poet around 1210. The number of roses used for festivities and for decorating chambers must have been as high during the age of the minnesingers as it had been in imperial Rome when rose petals were strewn in swimming baths.

The beauty of Nature had been re-discovered in Europe; its praises were sung and captured on canvas. As if the world were blossoming anew, flowers were

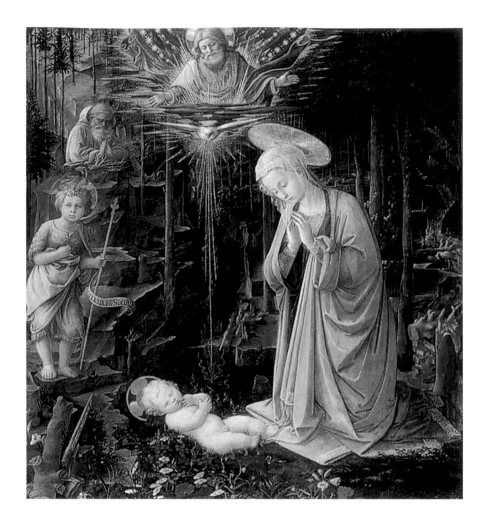

incorporated into every painting, the plant world having become an accepted part of the message of a painting. Italian painters responded to the verism that Dutch painters quickly perfected in their depictions of fruit and vegetables. Flowers even appeared among rocks in the depths of the forest to delight the Christ Child and as a sign of a paradise to come (fig. 5). God, the creator of the universe, wanted flowers to please not only the eyes of mortals, but also the souls of immortals.

During the Renaissance, Virgil's pastorals and Ovid's *Metamorphoses* gained new significance. The goddess Flora assumed a role that she had never previously had. In 1482, she was given her own special monument by the painter Sandro Botticelli. In his painting *La Primavera*, commissioned by the Medici's, he portrays the metamorphosis of the Greek nymph Chloris into Flora. She was abducted by Zephyrus, god of the west wind, and was then elevated to the position of goddess of flowers; as such, she was allowed to determine the beginning of spring on Earth. Flora scatters red and white roses before her; many flowers adorn her dress and she is seen stepping through a meadow full of spring flowers, as still seen around Florence today (fig. 6).

fig. 5 Fra Filippo Lippi,
Adoration in the Forest, 1459,
Gemäldegalerie, Staatliche Museen zu Berlin,
Preussischer Kulturbesitz, Berlin

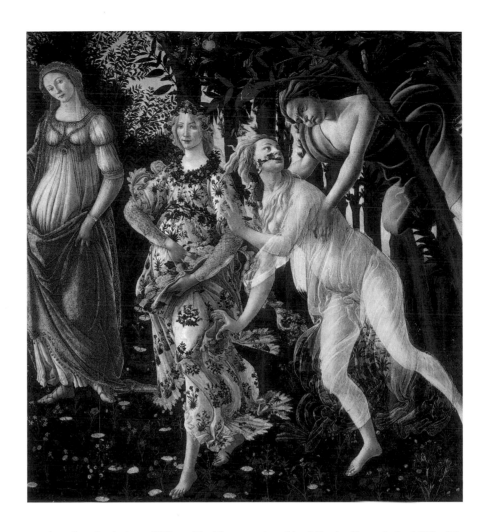

Another depiction of Flora (fig. 7) was painted by Nicolas Poussin in 1630–31. Flora is seen strolling through her kingdom, scattering flowers as she goes. To her right, the youth Hyacinthus holds his hand to his forehead where he had been struck by Apollo's discus. Despite divine aid, the youth dies. Ovid describes the scene in his *Metamorphoses*:

"… yet he applied his art in vain, for the youth's wound could not be cured. As in a garden where violets, poppies or yellow-tongued lilies lie broken, unable to stand erect, and must hang their heads and gaze upon the ground, so did the head of the dying Hyacinthus droop."

The one consolation is that Hyacinthus lives on as the hyacinth and re-appears on Earth each spring. Beside him, Aphrodite's favourite Adonis regards the fatal wound inflicted upon him by a boar. Pheasant's eye and anemone commemorate him. In front of them sit Crocus and Smilax, an unlucky pair of lovers who were transformed into saffron and bindweed. Narcissus admires his own reflection in a large basin of water held up for him by Echo, a mountain nymph. On the far left, Ajax falls onto his sword. It is said that an iris sprang from his blood, but Poussin

fig. 6 Sandro Botticelli, detail from *La Primavera* (Spring), 1482, Uffizi Gallery, Florence

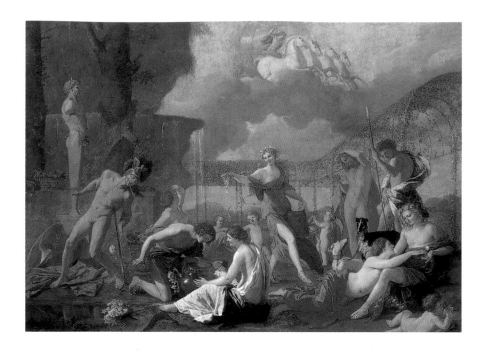

has painted a large carnation of a type unknown in antiquity. All these mythological figures have triumphed over their ill-fated amorous adventures; having died young, they are resurrected as beautiful but short-lived flowers and so have become symbols of death and renewal.

The goddess of flowers strolls through blossoming meadows whose fertility is the responsibility of the goddess of love, the Greek goddess Aphrodite, or the Roman equivalent Venus. Using the power of love, Flora was able to tame the harsh masculinity of nature and to create harmony between the greatest of polarities. To the delight of the gods and mortals, the goddess of love ensures the creation of new life and that all seeds flower, ideas that are symbolized by Venus's triumph over

belligerent Mars. A favourite setting for the depiction of love's triumph over war is a field of flowers that is protected and shaded by a myrtle grove, such as was sacred to Venus (fig. 8).

The European plant world began to change at the end of the sixteenth century. From 1556 onwards, the oriental bulbs that would transform Europe's gardens began to appear, foremost among them the tulip. A short while later, many New World flowers arrived in Europe for the first time. The science of botany broke away from medicine, to which it had long been subordinate, and the new flowers were introduced to the public in countless books (fig. 9). This onrush of myriad flowers is transformed into allegorical terms by having Flora surrender the victor's

laurels to Natura for her ability to change into hundreds of different species. An interaction is created between the myths of antiquity and the changes wrought by new geographical and scientific discoveries. The reason why Ovid's *Metamorphoses* enjoyed tremendous success around this time is possibly because the work was regarded as a poetic attempt to idealize the change that people were experiencing. The tulip's great success, too, can be attributed to its ability to grow in different shapes and colours.

This was the age of the Reformation and Counter-Reformation and, in the view of the Jesuits, God's character and wishes are clearly manifested in His creation and His will can be seen in the magnitude of nature. Every flower contains a hidden message that an attentive observer can interpret. A humble soul can draw a moral lesson from every rose, peony or columbine. The rose, for instance, exudes the sweet perfume of virtue; the sunflower shows how good it is when human actions correspond to divine will; the blue hyacinth encourages us to meditate upon God and heaven; while the crown imperial reminds us of the futility of human power. Floral still lifes encourage the observer to reflect on moral and religious issues. Cheerful souls see God's loving kindness in the beauty of flowers; more serious types, if they are familiar with the symbolism of flowers, can derive edification by reflecting on the hidden meaning of certain species. However, whether they are optimistic or melancholic, the messages communicated by flower paintings develop and change according to their context. Joseph Werner the Younger's gouache of 1685 of Flora in stone crowning a monkey with a wreath provides a striking example. Perhaps the painter wanted to denounce the symbolism attached to flowers in his day as completely outmoded. The monkey's imitative instinct is compared to the attitude of those for whom each flower had a hackneyed, obsolete and self-perpetuating symbolism (fig. 10).

fig. 9 Girolamo Pini, detail from *Bulbs and Year-Old Plants*, 1614, Musée des Arts Décoratifs, Paris

Spring is always associated with the reawakening of nature and flowers. *The Month of April* (see p. 19) shows a young lady in her garden surrounded by tulips and auriculas, the favourite flowers of her day. The lines of a poem by John Clare (1793–1864) are particularly fitting:

Flowers, oh flowers, your name alone

In the depths of winter

Revives spring and dreams of childhood.

Although a symmetrical garden can still be seen in the background, it was around the mid-eighteenth century that Jean-Jacques Rousseau advanced his theories of nature in which he called for gardens with no order or symmetry; he demanded Elysian fields where garden flowers and wild flowers could grow side by side. Even Marie Antoinette was influenced by this thinking and had meadow flowers planted in her Trianon gardens at Versailles. In 1785, Louis XVI commissioned Gerard van Spaendonck to paint a floral still life. The offering to Eros shown on the plinth and the flowers that comprise the bouquet make it clear that this painting is an allegory of love. Far removed from the moral lessons of Baroque bouquets, worldly bouquets like this served private matters of the heart (fig. 11).

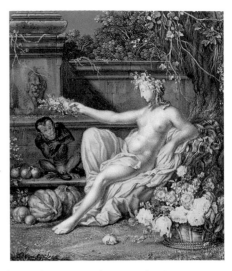

fig. 10 Joseph Werner the Younger, *Flora Placing a Wreath on a Monkey's Head*, 1685, Gemäldegalerie, Staatliche Museen zu Berlin, Preussischer Kulturbesitz, Berlin

More severe is the symbolism adopted by Philipp Otto Runge in his painting *Morning* of 1809, in which the new day is used as an allegory of life and the transient condition of man and nature. To reinforce this message, the artist painted flowers in the classic colours of white, red and blue. Lilies, roses and irises are in fact flowers which, even in ancient myths and in Christian symbolism, were associated with Venus, Iris, Aurora and Mary (fig. 12).

1818 saw the publication in France of a book on the language of flowers that revealed a whole new world to its spellbound readers. As in previous centuries, the literature of antiquity and the Christian symbolism that arose from it formed the basis of this reference book. Above all, however, it was also based on the rediscovered works of the minnesingers and Middle Age romances and was additionally influenced by contemporary reports about a secret flower code, known as "sélam", that operated among the ladies of eastern harems. Knowledge of flowers native to the Old World, as well as of others which had long since become well-known, was based on these sources. Newly-coined and usually unconvincing meanings were applied to many flowers from the New World. In the salons of the bourgeoisie, these symbols were used to express or awaken feelings. The flower as a "messenger of the heart" became hugely popular in the nineteenth century.

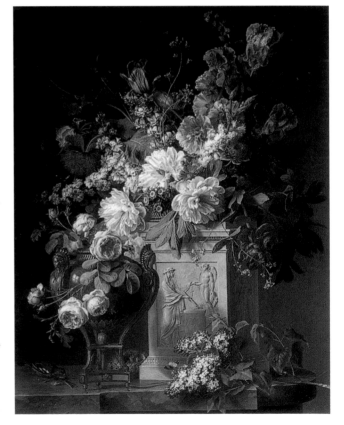

fig. 11 Gerard van Spaendonck, *Bouquet on an Antique Plinth*, 1785, Musée national du château, Fontainebleau

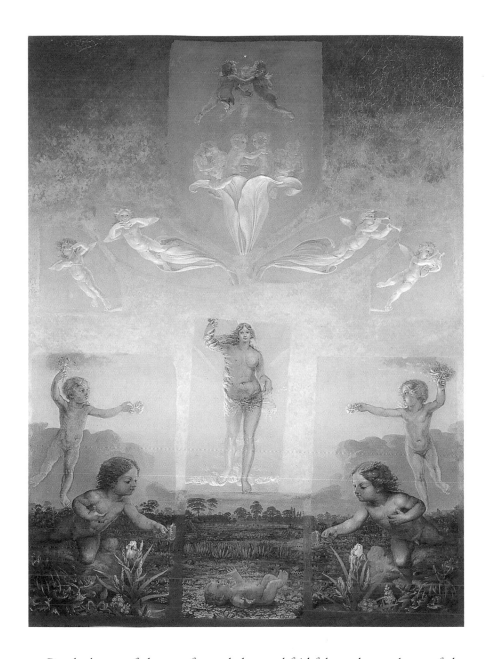

People dreamt of the age of courtly love and faithfulness that made use of the sentimental "language of flowers". This interest in the world of mediaeval thought and the mystical and religious meanings associated with the symbolism of flowers is reflected particularly well in wall hangings by William Morris (fig. 13).

Towards the end of the nineteenth century, artists began to develop a new relationship with the natural world. Flower paintings inspired by the close observation of nature came to replace fantastic bouquets with multiple meanings and references. Around 1870, Auguste Renoir stated: "I paint flowers and simply call them flowers; they do not have to tell a story". As an illustration of that point, Vincent van Gogh painted his gloriously yellow sunflowers a little later (fig. 14).

fig. 12 Philipp Otto Runge,
Morning, 1809,
Hamburger Kunsthalle, Hamburg

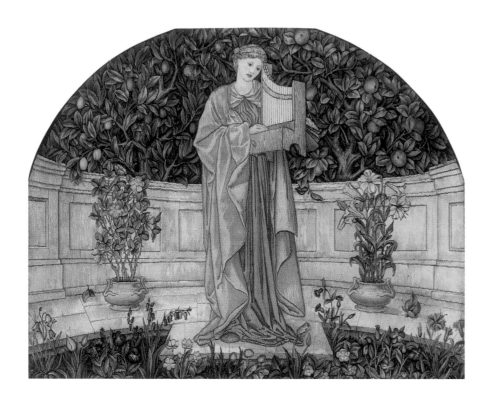

Throughout the ages flowers have played an important role in expressing feelings, or when joyful or sad news had to be delivered. Their scent stirs memories and their colours are associated with certain qualities. For centuries, red roses have been seen as a sign of love and affection, white lilies are the epitome of innocence and purity and blue flowers suggest faithfulness and romance. We can "say it with flowers" in just the same way that our writing can be elaborately "flowery".

The following pages give an insight into the "language" of popular flowers. Their meaning and symbolism are described as well as how these may have changed over time. Not least of all, the reader will find these pages useful when creating a suitable bouquet for a particular occasion.

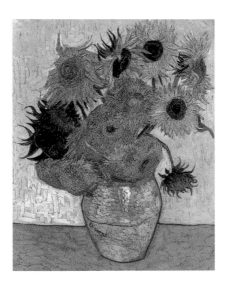

The Flowers

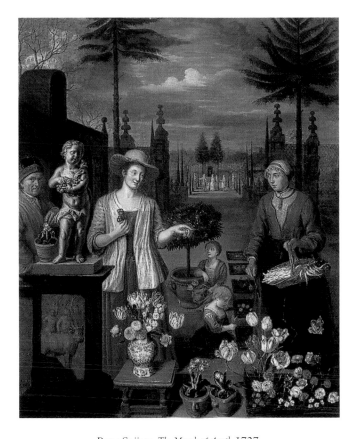

Peter Snijers, *The Month of April*, 1727,
Musées royaux des Beaux-Arts de Belgique, Brussels

The Authors

Marina Heilmeyer MH

Susanne Weiss SW

For further information
on the paintings illustrated
please see pages 90–93

Anemone

Anemone coronaria

The anemone's name is derived from the Greek *anemos*, the wind, because its delicate flowers appear to open in a gentle spring breeze and because its blossom is so short-lived, like a breath of wind. For these reasons the anemone has become a symbol of transitoriness.

This lovely red flower originated in the Near East and have been found throughout the Mediterranean since prehistoric times. The fragile and fleeting beauty of the anemone's blooms, a delightful sight in Greek spring meadows, simply cried out for a mythological interpretation. The flowers came to be associated with the lovers Aphrodite and Adonis, and so became a symbol of suffering and death. They developed from the tears of a devoted Aphrodite mourning the death of her beloved Adonis whose young blood is said to have engendered the pheasant's eye, a close relation of the anemone. The flowers were also seen as a symbol of rapidly-fading youth. The anemones, or windflowers, that arose from Aphrodite's tears became a symbol of a woman's quick-drying tears— Aphrodite is said to have recovered swiftly from her lover's death. This is why anemones came to be seen as a symbol of endangered or ephemeral love.

The Roman scholar, Pliny the Elder, considers the anemone one of the most suitable flowers for inclusion in a wreath. He also mentions their

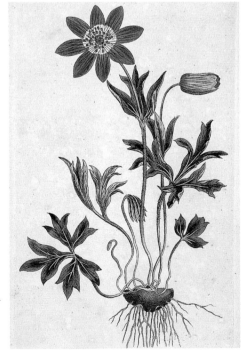

medicinal value; they not only relieve headaches but also inflammation and pain in the abdomen. He emphasizes their almost sacred importance as the first flower of the year, saying that the very first one to blossom should be eaten to ensure protection from illness throughout the rest of the year.

The significance attributed to anemones by the ancients resurfaces in the Middle Ages when they are regarded as symbols of parting, suffering and death. The red colour of the flowers is to remind us of the self-sacrifice of Christ and the martyrs. Meditative contemplation of the anemone should make one's heart receptive to the message of the Holy Spirit. During the Renaissance, the metamorphosis of youth into a beautiful flower was understood as a symbol of the brevity of human life, while later interpretations saw in the anemone's rapid decline a symbol of the transience of everything human, Along with the carnation, tulip, auricula, hyacinth, ranunculus and primula, the anemone was one of the seven most important garden flowers in the seventeenth century. Cultivated in countless shapes and shades, the anemone became every gardener's pride.　　　MH

left: the garden anemone, from *Curtis Botanical Magazine*, 1791
right: Jean-Michel Picart, *Flowers in a Carafe*, *c.* 1650

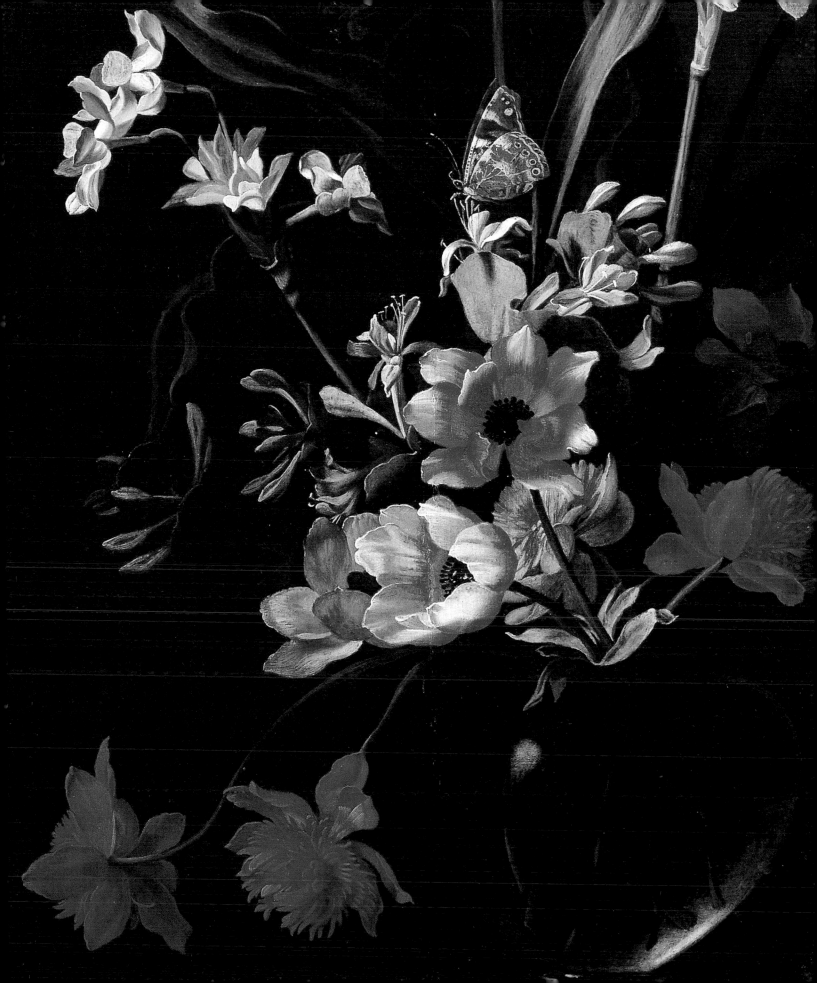

Aquilegia

Aquilegia vulgaris

In outline, the mysterious flowers of the aquilegia, or columbine as it is also known, look like a pentagon. To draw them, an artist need only make use of the proportions of the 'golden section'. With its delicate curlicues and incurved spurs, the aquilegia looks as if it might have been invented by Gothic artists. Indeed, the flower afforded artists and mystics of the Gothic era with countless opportunities for spiritual, mathematical and religious interpretations. Because of the pentagram concealed within it, the flower gained a reputation as a plant with powers to ward off evil.

There is no clear explanation for the Late or Middle Latin name *aquilegia* that monks gave to the columbine. The term may derive from the Latin *aquila*, the 'eagle', because the spurs of the flower resemble an eagle's hooked beak and talons. The shape of the bloom's nectar gland does slightly resemble a dove, hence the English name columbine (from Latin *columba*, 'dove'). This in turn led to the columbine taking the place of the dove as the symbol of the Holy Ghost. The seven columbine flowers represent its seven offerings: wisdom (*sapientia*), reason (*intellectus*), counsel (*consilium*), strength (*fortitudo*), science (*scientia*), piety (*pietas*) and fear (*timor*).

The work by Rachel Ryusch shown here depicts all seven columbine flowers. The picture was painted

XIII.6. *38 Ranunculaceae.*

1072 Aquilegia vulgaris L.

Harlekinsblume.

between 1690 and 1730—a period in which the meaning of symbols was shifting from the sacred to the profane. It cannot therefore be ruled out that the painter's true intention was in fact to play an intellectual game with the qualities attributed to the individual flowers. Between 1430 and 1580, the columbine appeared in many paintings as a sign of redemption and of the triumph of life over death. It is the flower of the Saviour and, in pictures of the Virgin Mary, is understood to be an allusion to the coming salvation through Christ's death on the Cross. Even in depictions of the Fall of Man, it is found symbolically growing at Adam's feet. Where a flight of steps leads up into heaven in pictures of the Last Judgement, the aquilegia is present as a mediator between the earthly and heavenly spheres. Its leaf, divided into three parts, represents the Christian Trinity.

Aquilegia was planted in the gardens of monasteries and castles from the twelfth century onwards as a medicinal plant and a garden flower. It was used as protection both against the evil spells that sapped a man's strength and as an aphrodisiac. MH

left: the flower and fruit of the aquilegia, 1840
right: Rachel Ruysch, *Flowers in a Vase*, early 18th century

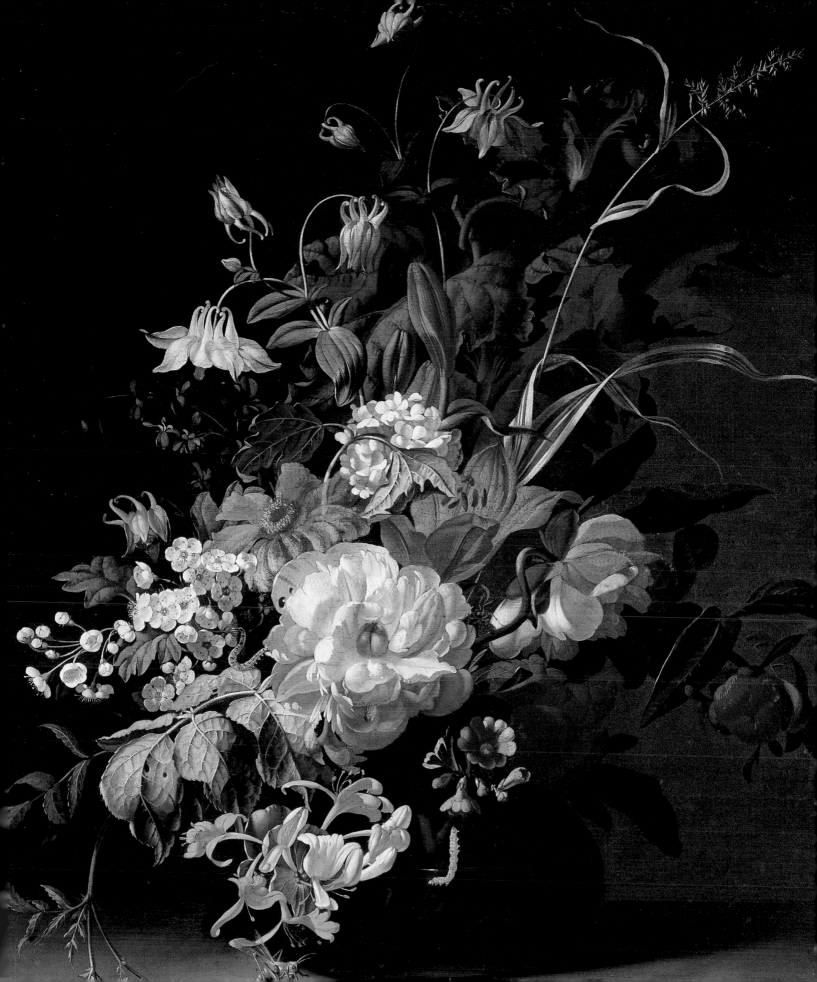

Camellia

Camellia japonica

The most sought-after and expensive flowers of the nineteenth century; a symbol of the transcience of life; delicate and elegant

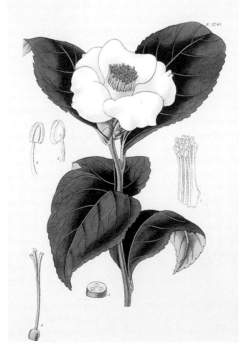

"The camellia is close to the rose; it is delicate, limpid and pure and is often full of splendour. But it always has an air of strangeness about it and presents itself with genteel propriety. The softness … the *sweetness* of the rose it simply does not have. And that's to say nothing of its scent." These lines were penned by the Austrian writer Adalbert Stifter in 1857 about the camellia—*the* fashionable flower of his day and, indeed, century. It is native to East Asia where, under the Tropic of Cancer, most of the 250 varieties grow.

The earliest European description of it dates from 1692, although it was not until 1739 that the first two camellias were introduced into Europe by the Bohemian missionary and botanist Georg Joseph Kamell, in whose honour the flower is, in fact, named. In Japan, the camellia is a symbol of friendship, grace and harmony. For the samurai, the flowers of the *Camellia japonica* symbolised death and the transience of life. In 1808, the Dutch presented Empress Josephine, Napoleon Bonaparte's first wife, with a red and a white camellia. Their gift marked the start of a valuable collection of camellias at Josephine's private residence, Malmaison near Paris.

While the flowers of the camellia were often described as noble but cold beauties, they were undoubtedly the most sought-after, most favoured and most expensive flowers of the nine-teenth century and led to much financial speculation. A bridal bouquet of camellias was still a sensation at the end of the eight-eenth century; twenty years on, many nurseries had already started to specialise in cultivating these exotic Asian flowers. In his celebrated novel *La Dame aux camélias*, Alexandre Dumas, jnr., describes the fate of the courtesan Marguerite who is never seen at the theatre or at balls without a camellia bouquet in her hands. For twenty-five days at a stretch, she would carry a bouquet of white camellias and then, for five days, one of red camellias, the colours tactfully signalling her availability. The story's immense popularity and the heroine's tragic fate most certainly contributed to the nineteenth century's love affair with the camellia.

There was no end to the number of flowers required, no waltz or cotillion danced where a lady did not have a bouquet of camellias, no fancy-dress ball where at least some ladies did not come dressed as camellias. The flowers were cut short and bound by wire to huge hats or attached in abundance to dresses. The elegance and colourfulness of the flowers and the durability of the leaves made the camellia the ideal festive decoration. MH

left: flower and stamen of a camellia, 1787
right: Ferdinand Waldmüller, *Birthday Table*, 1840

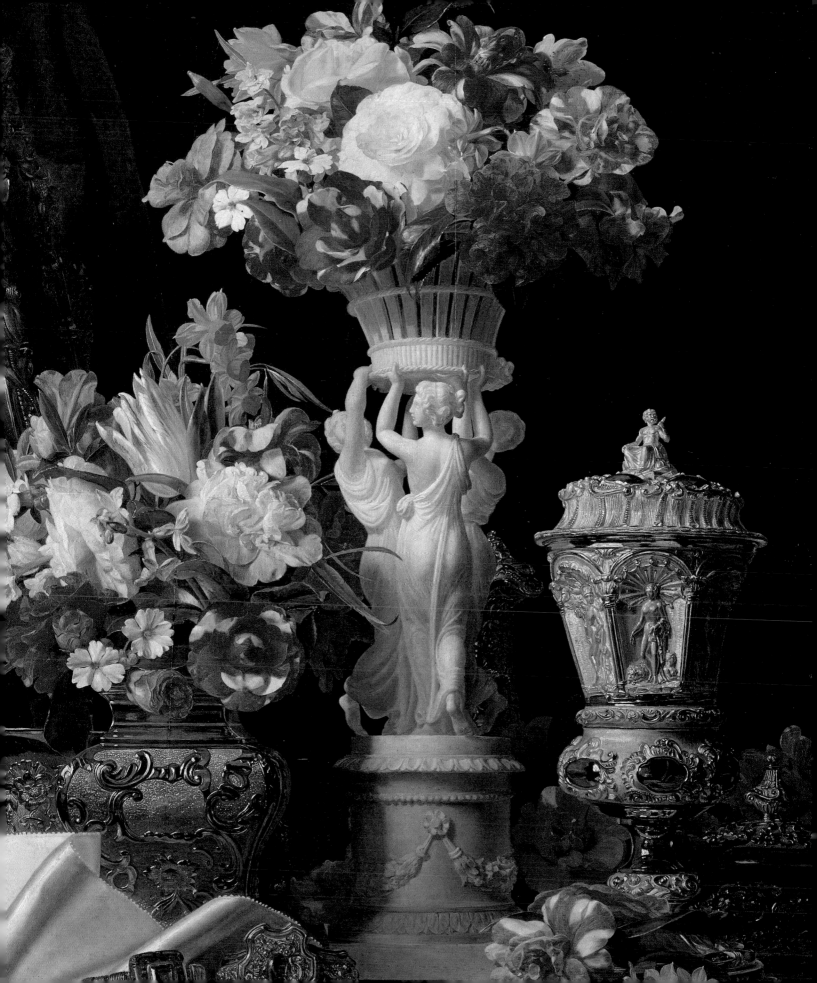

Carnation

Dianthus caryophyllus

Bravery, love and friendship;
vanity and pride; socialism; the
symbol for Mother's Day

The carnation may lay claim to divine roots. The animals belonging to Artemis, the goddess of hunting, had been frightened off by the sound of a shepherd playing the shawm—a form of oboe. She was so furious that she punished him by tearing out his eyes. Immediately gripped by remorse, however, beautiful carnations blossomed in their place.

Legend has it that Louis IX of France discovered the carnation in Africa where he used its sap to treat his soldiers stricken by the plague. The carnation then made its way back to France with the Crusaders since when it has been regarded as *the* French flower. In the seventeenth century, troops sported carnations as a sign of their bravery. French aristocrats wore a red carnation in their buttonholes when they were led to the guillotine and Napoleon chose carnation red as the colour for the ribbon of the Legion of Honour. In England, the upper classes turned their noses up at the carnation, resulting in it being adopted as the "workers' flower", regarded by the "common folk" as a symbol of love and bravery. To this day the carnation remains the flower of socialists and Social Democrats alike. Business for carnation growers flourished and, in the 1840s, the eternally blooming carnation that we know today was first propagated.

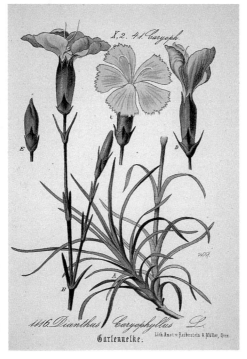

In the Roman Catholic tradition, the carnation has been a symbol of the Virgin Mary since the thirteenth century, appearing alongside her in countless paintings. It is, however, often associated with Christ's Passion—albeit in a roundabout way. The name carnation was applied to the gillyflower in the fifteenth century, having earlier been used for the clove. Since the shape of the exotic spice resembles a nail, the *dianthus* appeared in many scenes of the Crucifixion. The clove lost its reputation as an aphrodisiac to the carnation, turning the latter into a symbol of love, fertility and betrothal and, as such, it has figured in paintings of brides since the Middle Ages.

The carnation was also associated with vanity and pride, possibly because it was at first a rare and valuable flower. Poets sang its praises as a sign of friendship because it keeps its colour to the last. With so many contradictory meanings and associations, it is little wonder that the carnation was also referred to disparagingly as merely a fashionable flower of no great meaning. Anna Jarvis of Philadelphia, on the other hand, did not let this view influence her when, in 1907, she chose the carnation as the symbol for Mother's Day. SW

left: flowers of the garden carnation, 1840
right: Jacob Marrel, *Flower-adorned Cartouche with a View of Frankfurt*, 1651

Cornflower
Centaurea cyanus

Loyalty and constancy; a symbol
of the Virgin Mary; healing powers;
intensive, bright blue colour

Among the loveliest items to accompany Princess Nes Chonsu on her final journey was a garland of green placed around her neck intertwined with sprigs of the bright blue oriental cornflower. At the start of the New Kingdom of ancient Egypt, it became customary to decorate mummies with floral wreaths. A garland of cornflowers had once been presented to Horus and Osiris as a sign of victory over the Gods' enemies and one of Tutankhamen's famous floral necklaces also included cornflowers.

Much later in time and in a country further north, the cornflower again found its way to royal favour when Germany's Kaiser Wilhelm I chose the flower as a personal emblem. The cornflower, *Centaurea cyanus*, is beguiling mainly because of its colour, a bright and pure blue such as is seldom found in nature. For the German Kaiser, it was the epitome of "Prussian blue". In Christian symbolism, cornflowers represented the Virgin Mary and, during the Middle Ages and the Renaissance, it became common to portray Mary with a wreath of cornflowers. Blue stands for loyalty and, as a symbol of loyalty and constancy, cornflowers found particular favour and were planted in large numbers, especially during the sixteenth century. But nature is known for its occasional vagaries and the cornflower can change the colour of its flowers to purple and white. This undermined the flower's reputation as a flower of loyalty, and for some people, the flower even came to represent the exact opposite.

The image of bright blue flowers in a cornfield brings to mind an anecdote about their origin. Flowers with such an intensive colour could only have come from heaven itself. Heaven had once complained that the cornfield had no gifts to proffer in the way that flowers scent the air, trees rustle in the wind or birds sing. But because the ears of corn were unable to reach heaven, heaven decided to come down to the cornfield and sowed small pieces of itself among the stalks. That is how the cornflower came by its colour and its name.

The cornflower was less popular among farmers, however, because its stems blunted their scythes. Nevertheless, it was also attributed with healing powers: brushing the first cornflowers over one's eyes would improve one's sight and prevent any swelling. Pliny records a tale about the blue flower's healing power. The centaur Chiron, after whom the genus *Centaurea* is named and who was the teacher of Asclepius, a god of healing, had been injured by a poisoned arrow. Chiron applied cornflowers to his wound and his condition improved. SW

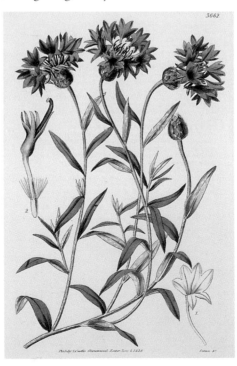

left: cornflowers, 1839
right: Daniel Seghers, *Vase with Flowers*, 1637

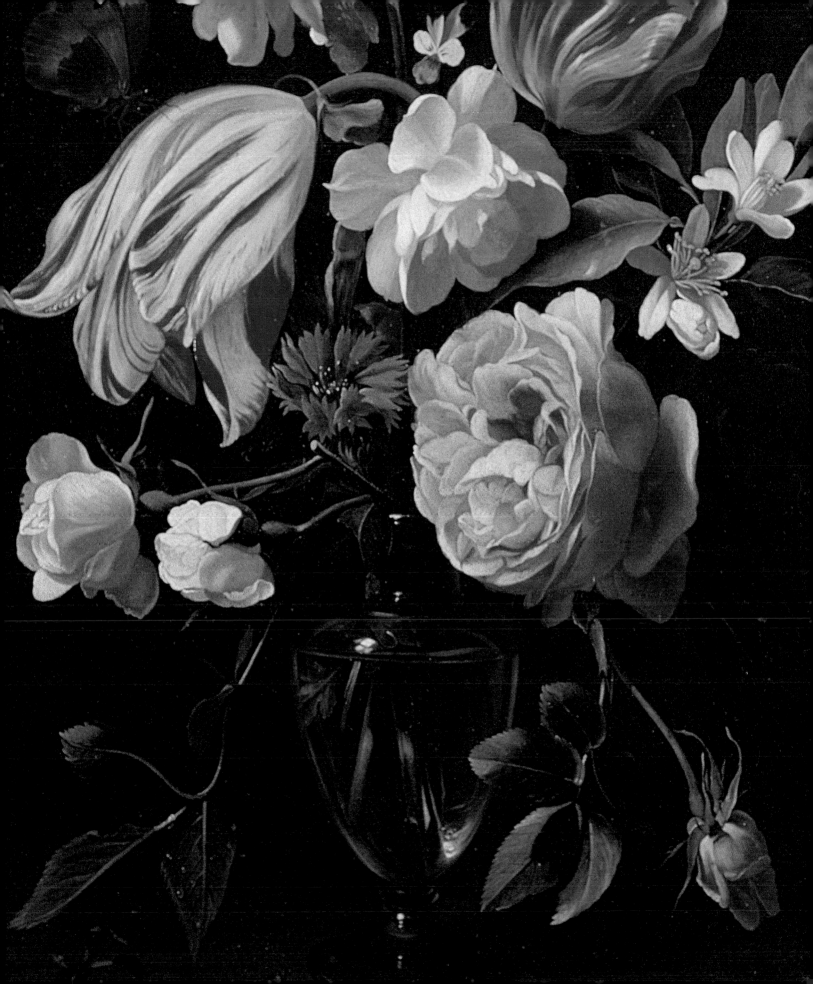

Crocus

Crocus vernus · Crocus sativus

A symbol of the Resurrection and heavenly bliss; renowned relative saffron used as seasoning, medicine, aphrodisiac and dye

Crocuses are multifaceted flowers: while many different species add colour to lawns and borders at the very onset of spring, others wait until September and into the late autumn before revealing their splendour, among them saffron or *Crocus sativus*. The lovely golden-yellow crocus, one of the varieties that blooms in spring, is seen here among a bouquet of flowers in a 1620 painting by Ambrosius Boesschaert. This crocus made its way to Europe from the Orient as a highly-prized curiosity and began to be cultivated here in 1597. Native to the northern shores of the Black Sea, the crocus, together with other equally marvellous bulbous plants, was grown for its attractiveness in the sultans' gardens in Constantinople. It stands out because of its unusual brilliance and rare combination of yellow, violet and burnt umber.

Its renowned relative is saffron, *Crocus sativus*, a flower that in autumn blooms on the hills of Greece and Asia Minor and whose colour and strong fragrance have been a source of pleasure since time immemorial. Besides the hyacinth, narcissus and lily, saffron is mentioned in the legends of the Greek gods and depicted in the earliest surviving frescoes from Minoan Crete. It was considered the epitome of things charming and sweet in terms of colour, scent and taste, even though it is associated with hallucination and ecstasy due to its heady scent. Legend

has it that Earth clothed herself with crocuses and hyacinths to greet Zeus and Hera on their wedding night atop Crete's Mount Ida and Aurora, the goddess of the dawn, unfolds her saffron-coloured veils when she appears across the sea each new morning.

Saffron was traded early on in history. Its golden-yellow flowers were picked, dried and sold for use as a seasoning, medicine, aphrodisiac and dye. Indeed, there is clear evidence that saffron was cultivated in antiquity as a commercial crop. The Arabs took saffron with them to Spain and the Crusaders returned with it from the Holy Land to northern and central Europe. Like so many flowers in Christian teaching, saffron became a symbol of the Resurrection and heavenly bliss. The Bible alludes to the crocus in Solomon's *Song of Songs* and confessors of the Christian faith in their wisdom were compared to shining crocuses. The ephemeral beauty of the crocus also gave rise in antiquity to a tale about its origins, a tale of metamorphosis that described the youth Crocus whose beauty attracted the attention of the nymph Smilax. He, however, remained cool and aloof. This aggrieved Aphrodite, the goddess of love, who transformed the unwilling youth into a flowering crocus and the fair Smilax into bindweed. MH

left: five different species of crocus, 1690
right: Ambrosius Bosschaert the Elder, *Bouquet of Flowers*, 1620

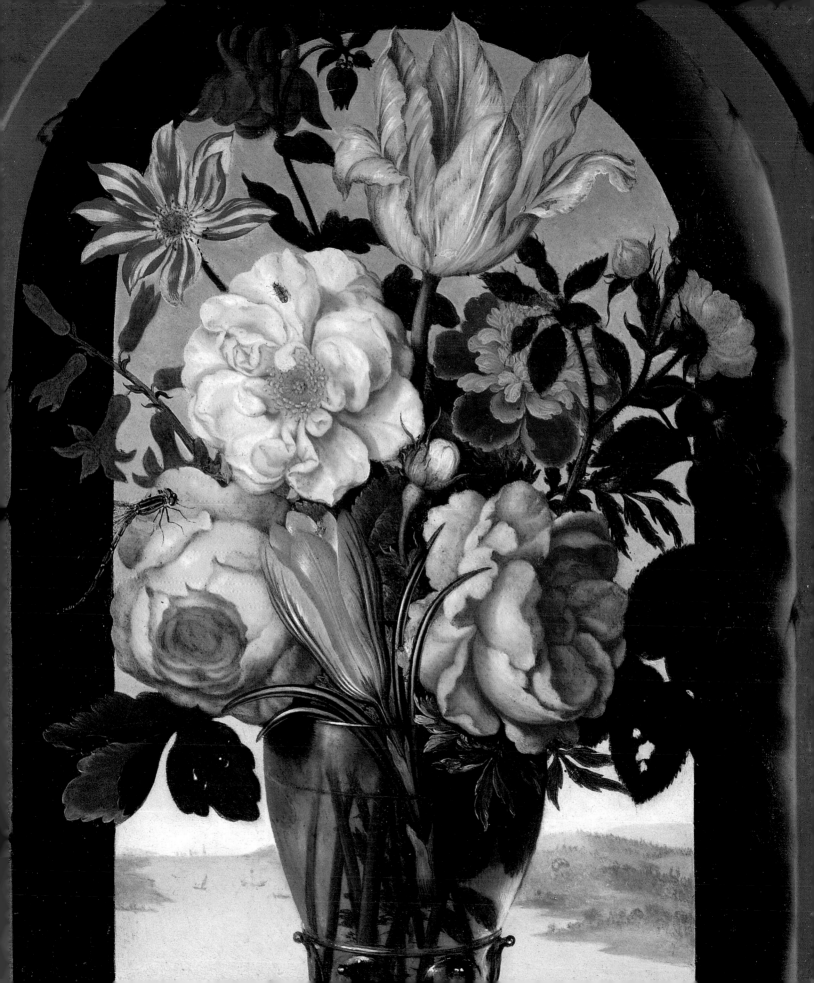

Crown Imperial

Fritillaria imperialis

Majestic flower of the high society; principal ornament of stylish sixteenth and seventeenth-century gardens; arrogance and pride

The crown imperial hails from the Orient. Native to the western Himalayas, it found its way westwards and was long cultivated in Persia. The French botanist Carolus Clusius imported the flower to Vienna from Constantinople in 1576. He cultivated it later in Leiden's botanic garden and named it the "Persian lily". Some interpretations saw in this imposing flower the "lilies of the fields" from the Sermon on the Mount. It does seem to have a certain affinity with higher things given that it was marked on coins minted under Herod.

Having been a sensation in Turkey around 1570—large sums were spent there on its cultivation—the crown imperial shortly afterwards became the principal ornament of stylish gardens of the sixteenth and seventeenth centuries in central Europe. Odd and extravagant things were popular—not just in gardens, but in paintings by the Old Dutch masters, too. The crown imperial had to be positioned carefully, however, as its smell is anything but enchanting! Even at that time, there was a competitive spirit among flower growers, with the number of bell-like flowers determining a grower's prestige.

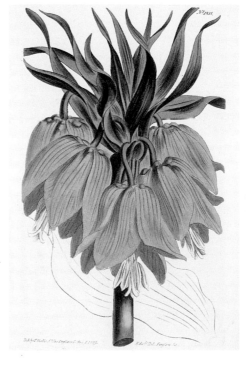

It was the physician of the Duke of Tuscany who gave the plant its name. He sent a drawing of the fritillary to John de Brancion, a member of the group around Clusius, and gave it the name *Corona Imperialis* on account of its majestic appearance and its nodding flowers surrounded by whorls of leaves. The flower retains its imperial title in later botanical writings but has had its crown replaced by an uninspiring "dice-box", which is the meaning of *fritillus*.

Yet it was not only the proud flower's name that suffered, for it was once said that the crown imperial inhabited Paradise. At the time, it bore its flowers upright and was so indescribably lovely that the other flowers looked up to it in admiration. They celebrated it and paid homage to it and this made the crown imperial conceited. But God punished it for its conceit since which time the flower has hung its petals in shame, shedding tears over its sad fate. Much sap is, in fact, secreted from the fritillary's flowers; it drips onto the ground and gives the impression that the flower is weeping. According to another legend, the tears shed by Christ on the Mount of Olives fell onto the crown imperial's petals, pressing them down in a sign of mourning. For all its tears and crushed pride, the crown imperial failed to find its way into the tales of ordinary folk. It remained a flower of fine society— in the Occident and Orient alike. sw

left: flower of the Crown Imperial, 1808
right: Jan Breughel the Elder, *Bouquet of Flowers*, after 1607

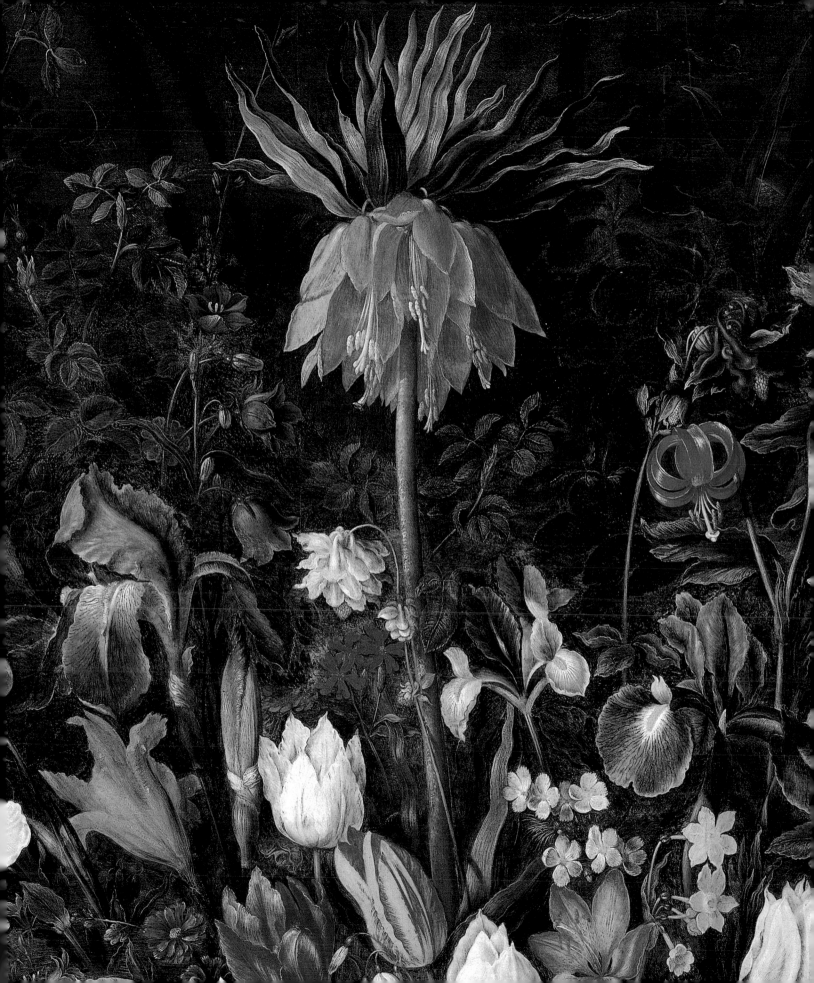

Daffodil

Narcissus pseudonarcissus · Narcissus poeticus

Vanity and death, resurrection and rebirth; the promise of eternal life; the flower of the underworld

The yellow daffodil—*Narcissus pseudonarcissus*—is one of the national emblems of Wales. Bunches of daffodils bring colour into the house in spring. The beautiful *Narcissus poeticus*, however, with its white petals and yellow centre—as seen in this magnificent still life by Roelant Savery—is better enjoyed outside in the garden because its fragrance is so overpowering. This flower, that was associated with the underworld, was given the name *Narkissos* by the ancient Greeks, which evokes the power of its narcotic scent.

Greek mythology tells the tale of Narcissus, a handsome youth who rejected the love of the nymph Echo. The gods then decided to punish him for his cold-heartedness. Stopping to quench his thirst at a spring in the forest, Narcissus fell in love with his own reflection in the water. He leant so far down towards his reflection that eventually he disappeared below the surface! Where Narcissus had been kneeling, a white flower sprang from the water's edge. Instead of the handsome youth, nymphs later found the lovely bloom; the youth's image now being reflected in the waters of the underworld for all eternity. This is how the genus narcissus became a symbol of vanity and death and is the reason why it is regarded as a flower of the spirits of the underworld.

Homer's *Hymn to Demeter* describes the famous episode with Persephone:

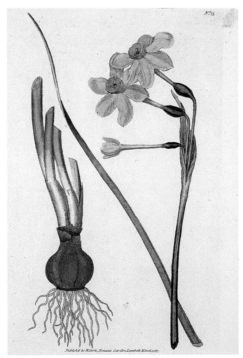

"Demeter's daughter was gathering flowers over a soft meadow, roses and crocuses and beautiful violets, irises also and hyacinths and the narcissus which Earth made to grow at the will of Zeus and to please the Host of Many, to be a snare for the bloom-like girl—a marvellous, radiant flower. It was a thing of awe whether for deathless gods or mortal men to see; from its root grew a hundred blooms and it smelled most sweetly, so that all wide heaven above and the whole earth and the sea's salt swell laughed for joy." When Persephone stooped to pluck a flower, the Earth opened and Hades carried her off to the underworld as his wife. Since then, Hades has worn a garland of narcissi on his brow and the flowers have been bound into wreaths for the dead or planted on graves.

Exquisite narcissus wreaths have come down to us from Graeco-Roman Egypt. Other cultures, too, associated the narcissus with death. At the time of the pharaohs, daffodil bulb skins were placed over the eyes, nose and mouth of a mummy and, as is the case with the mummy of Ramses II, they were also placed around his neck. In the Christian faith, the daffodil has been viewed as a symbol of Christ's resurrection and the promise of eternal life since the Middle Ages. MH

left: bulb and flower of a daffodil, 1787
right: Roelant Savery, *Bouquet of Flowers*, 1612

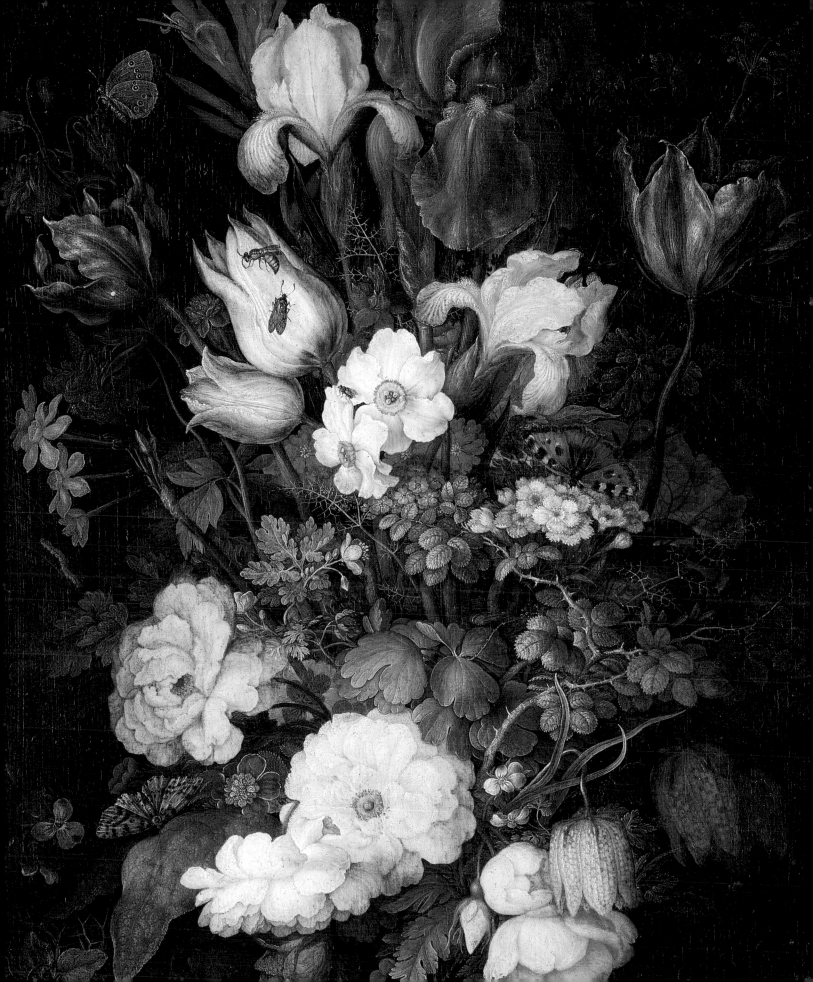

Daisy
Bellis perennis

The love flower; contempt for worldly goods; a favourite among lovers, poets and children

A popular oracle on affairs of the heart, this small and unassuming meadow flower found its way into people's affections long ago. The scourge of many a gardener, the daisy is, however, much loved by children and poets alike. It was named the love flower, *flos amoris*, or the sun's consort, *sponsa solis*, in the thirteenth century, being first extolled as "love's oracle" in the fifteenth century when the love-struck started picking off the petals to discover whether "s/he loves me, s/he loves me not; s/he loves me, s/he loves me not". The last petal to be plucked indicates love's measure. This is something that has remained popular to the present day.

The small flower became a favourite in England. In Geoffrey Chaucer's time, the flower was called the "e'e of daie" or "day's eye" which, over the years, became "daisy", the heart's favourite. The French named the white cluster of petals "Marguerite", derived from Latin "margarita", the pearl, as the buds of the daisy resemble pearls in a row. During the time of the troubadours, knights were permitted to include a *Bellis* in their coat-of-arms if the lady of their heart had granted their plea. Queens called Margaret decorated themselves with the flowers of the *Bellis perennis*, the "eternal beauty".

Daisies were sacred to the Germanic goddesses Freya and Ostara and

Aphrodite was associated with them during antiquity and the Renaissance. Roman Catholicism, however, sees the daisy, which seems to grow everywhere, as a symbol of the Virgin Mary and of a love that conquers all things. Since the sixteenth century, this flower has symbolized contempt for worldly goods. In Books of Hours, the tiny daisy implied that a virtuous person could learn something useful even from the smallest flower in God's creation.

The daisy's flowers reveal the thermostatic movement of its inflorescence: they open during fine weather in the morning and shut in the evening. As Alice experiences through the looking glass, daisies can also talk and wave about. During her adventures she comes upon "a large flower-bed, with a border of daisies and a willow tree growing in the middle." However, when they all start chatting at the same time she whispers: " 'If you don't hold your tongues, I'll pick you!' There was a silence in a moment and several of the pink daisies turned white." MH

left: Pierre-Joseph Redouté, *Daisy*, from *La Botanique de J.-J. Rousseau*, 1805
right: *Bellis perennis*, from *Curtis Botanical Magazine*, 1793

Forget-me-not
Myosotis palustris

The delicate flowers of this well-loved plant seem to reflect the blue of the sky. Its very name tells us that it has come to signify human longing for loyalty and lastingness. The flower has the equivalent name in several languages—*forglemmigej* in Danish, *ne m'oubliez pas* in French, *Vergissmeinnicht* in German and *non-ti-scordar-di-me* in Italian. One legend has it that God himself called it that because the plant was unable to remember the name it had been given when the world was created!

The flower has a central yellow spot and bears a certain resemblance to an eye—indeed, poets have transformed the blue eyes of many a maiden into forget-me-not-eyes. The name "forget-me-not" has existed since the fifteenth century, but it is now unknown which flower was originally meant.

One piece of advice from as early as 1419 stated that any conversation with a winsome lass should be about nice clothes and forget-me-not flowers. A short while later, the flower is found in paintings at the feet of the Virgin Mary or other saints. Greek botanists were the first to name the plant and called it *myosotis*, "mouse ear", after the shape of its leaves. They valued the plant's latent medicinal qualities and classified it in the group of medicinal plants. The forget-me-not's active ingredients were used to treat inflammation of the eye, ulcers, abscesses or general debility.

Folktales about the forget-me-not relate how the magical blue flower can help people attain their heart's desire. Those born under a lucky star are to tie it to a stick and use it to open invisible doors behind which all the treasures of the world are laid out. But it is now that the small blue flower raises its voice: "Don't forget the best thing of all," it warns, meaning that God's love and humility should be placed higher than all worldly goods and vain love of oneself. This is the message that the blue flowers have for the thoughtful observer when they peek out from still lifes below an array of resplendent flowers.

In the seventeenth century, it was thought that a submissive soul could profit from the moral lessons afforded by flowers. To observe the forget-me-not provided an opportunity to reflect on God, oneself and death. Even the smallest of flowers has a valuable lesson for virtuous souls.

The forget-me-not is one of the more restrained flowers in the garden. It draws attention to itself only when it grows in larger clumps and forms a colourful blue backcloth for tulips and lily of the valley.　　MH

left: flower and seed of the marsh forget-me-not, 1840
right: Balthasar van der Ast, *Still Life with Basket of Flowers*, 1640/50

Hellebore

Helleborus niger · Helleborus foetidus

Magical powers; cures diseases; wards off evil spirits; highly poisonous; flowers in snow and ice

One plant of the hellebore genus, the Christmas rose, opens its large, white flowers around the winter solstice when the ground is covered in snow and ice and in time for Christmas festivities. It marks the start of a new cycle in the seasons long before the first flowers announce the arrival of spring. A plant that was able to open its flowers surrounded by snow and ice had to have magical powers, it was believed—powers that could protect both man and beast from illness and cold, or so it was hoped. It was quickly discovered that the attractive, innocent-looking white flowers in fact belonged to a highly poisonous plant with pitch-black roots. Although its consumption can be fatal, if administered in small amounts it was reputed to cure or relieve madness or epilepsy and have a positive influence on mania and melancholy. In accurately measured doses, the different varieties of Helleborus were effective emetics and laxatives, but a substance present in their roots could also be used to poison enemies, as was reported by Attalus, King of Pergamum. Anyone trying to unearth the roots had to take great care to prevent the plant's magic powers from taking immediate effect.

The Christmas rose and related plants of the hellebore genus came north with the Romans. Because the plant can cause severe sneezing, hellebore is sometimes known as the "sneeze weed". However, carrying a piece of its root guaranteed a long life and banished evil spirits and disease. Those who were betrothed, also did well to carry a piece of Christmas rose root around with them to ward off evil influences.

Until into the sixteenth century, it was believed that powdered hellebore mixed with sugar rejuvenated old folk. If the Christmas rose flowered in time for Christmas, a fruitful year could be expected. During the winter solstice, twelve buds on a Christmas rose in water were used to make a weather forecast for the following twelve months. Farmers were keen to plant the Christmas rose beside their barns or to hang its dried flowers on stable doors to protect their animals from disease. The Christmas rose was viewed as a symbol of being released from fear and so was used therapeutically.

Vita Sackville-West's famous garden at Sissinghurst contained three varieties of hellebore—*H. foetidus* (stinking hellebore), *H. viridis* (green hellebore) and *H. niger* (black hellebore or Christmas rose)—whose attractive leaves and flowers won the plant new respect among gardeners and made it something of a status symbol in elegant gardens. MH

left: rootstock and flower of the stinking hellebore, 1828
right: *Helleborus niger*, from *Curtis Botanical Magazine*, 1787

· 40 ·

Honeysuckle

Lonicera caprifolium

Ravishing, sensuous fragrance;
a symbol of lasting pleasure,
permanence and steadfastness

"Strength is pleasured by weakness and ofttimes the latter lends the former its grace. With loving intimacy, the young honeysuckle entwined the gnarled trunk of an ancient oak with its supple and delicate shoots." So wrote the author of one of the numerous publications on the qualities of plants that appeared at the beginning of the nineteenth century. In the language of flowers at that time, the encounter between the honeysuckle and the oak implied that love could even unite a shy country lass and a proud warrior. Perhaps the lovers spent the night in an arbour adorned with honeysuckle, planted there on account of its ravishing, sensuous fragrance. If the night is especially mild, the honeysuckle's fragrance is all the more exhilerating. In Greek mythology, Lycinna stayed with her daughter Chloe "for as long as the honeysuckle blooms" while in the company of Daphnis, whose own mother sat beside him in a honeysuckle arbour. Daphnis was passionately in love with Chloe, but the lovers lived far apart and saw each other rarely. The goddess of love answered his prayer to make the honeysuckle blossom last and last, and the lovers were able to spend longer together.

Even back in the Middle Ages, the honeysuckle was a symbol not only of lasting pleasure, but of permanence and steadfastness, too—a meaning that is still attributed to it today. In keeping with the fashion of the times, Rubens

painted himself and his new spouse Isabella Brant standing in front of a honeysuckle arbour in the year of their marriage, 1609. In an old folk song, however, honeysuckle also symbolises excess that can spell disaster. The daisy is then proffered as an "antidote" and a symbol of moderation:

In healthy strands it grows, and from its flowering ends,
A sickness then all flows—take heed and make amends!
I've seen it with my skill, the honeysuckle's power,
Avoid it if you will, the daisy is your flower!

The eighteenth-century Swedish botanist Carl von Linné gave honeysuckle the Latin name *Lonicera caprifolium* after the famous German botanist Adam Lonitzer (1528–86). The mediaeval Latin *caprifolium* (capra = goat; folium = leaf) was initially used to describe privet. Because the leaves of the honeysuckle, like privet, are a favourite food of goats, the name came to be applied to the attractive climber with the heady fragrance. Other interpretations see a similarity between the honeysuckle's leaves and goats' hooves. This of course implies that honeysuckle can climb as expertly as any goat—and entwine a lover's arbour. SW

left: flower and fruit of the honeysuckle, 1840
right: Maria van Oosterwyck, *Flowers and Shells*, 1740

H yacinth

Hyacinthus orientalis

Intense fragrance; symbolizes death and revival; used to delay sexual maturity

The hyacinth belongs to the group of garden flowers that found its way from the Orient to Europe in the mid-sixteenth century, having come from the gardens of the Seraglio in Constantinople in 1576. It rapidly became a firm favourite in European gardens and, like the tulip, the hyacinth triggered off a wave of frenzied enthusiasm and was passionately sought out by collectors, particularly in the Dutch city of Haarlem where the first blooms were cultivated around 1600.

Hyacinthus orientalis is native to southern Turkey and must have been found in early Greek gardens, too. Homer certainly refers to it as a fragrant plant with flowers as blue as birds' eggs. Legend has it that Apollo loved the handsome Spartan youth Hyacinthus who was also desired by Zephyrus, the god of the west wind. As his love was not reciprocated by the youth, Zephyrus caused Apollo's discus to strike Hyacinthus on the head, killing him. The Delphic god was unable to save the youth's life and, inconsolable at his early death, he caused a flower to grow out of his beloved's blood. In this way, Hyacinthus was able to live on as a flower in the realm of the goddess of flowers, Flora, and be revived each spring. He therefore came to symbolise Nature's death and revival. Like the violet and the crocus, the hyacinth is also listed in descriptions of the flowery meadows inhabited by the gods. Youths would delay their sexual maturity if they ate the bulbs and roots of the hyacinth, it was said. As late as the Renaissance, hyacinth roots were crushed to make a paste that was applied to the genitals to prevent the growth of hair.

Hymen, the god of marriage, scattered fragrant crocuses and hyacinths on the bridal bed of the newly-wed gods Zeus and Hera, on the top of Mount Ida on Crete. Following this example, hyacinths were frequently used as wedding flowers during the Italian Renaissance.

When French Huguenots fled to Berlin in 1685, they took hyacinth bulbs with them and started a flourishing trade that reached its peak around 1830. Bulbs were placed in specially developed, water-filled glasses into which the roots trailed, while perfectly formed blossoms sprouted upwards. Although the fragrance of the hyacinth is almost narcotic in its intensity, its praises are widely sung in oriental poetry and the shape of the hyacinth's flowers is compared to the curly locks of a loved one's head: "sweeter to me than musk is her fragrant hyacinth hair."

MH

left: flowers and bulbs of the oriental hyacinth, 1845
right: Daniel Seghers, *Flower Garland with Mary, Christ and St. John as a Boy, c.* 1645

Iris

Iris

A symbol of faith and authority;
victory and conquest but also pain;
a protection from evil spirits

Iris was given its generic name in the second century BC. The flower's iridescent shades of blue, purple, yellow and silvery white may have been the reason why it took its name from Iris, the messenger of the gods who makes her way across rainbows to deliver her messages and to connect heaven and earth. Iris also guides the spirits of girls and women into the afterworld—which is why irises are still often placed on women's graves in Greece today. The symbolism of hardly any other flower has been so strong and survived over such a long period as that of the iris. From New Kingdom Egypt to Greece, from Ancient Rome through the Middle Ages and the Renaissance up until the present, the iris has always been a symbol of authority and religious belief. As far back as Ancient Greece, the iris owed its other name—the sword lily—to the striking shape of its leaves.

Not only its irresistible beauty makes the flower so significant, but also its healing powers, identified early in history, and the aromatic substances that lie hidden in its rootstock.

Hippocrates discovered a remedy for sexual complaints in the root of the iris and, even in modern times, teething children are frequently given a piece of orris root to soothe their aching gums.

Anticipating the language of flowers in the nineteenth century, the Greek poet Anacreon described the iris, in the fifth century BC, as a symbol of the pain of unrequited love. To his countrymen, its leaves signified polished rhetoric, a "sword of the intellect". This same interpretation is found again centuries later in Christian symbolism, albeit in slightly altered form.

Besides violets and hyacinths, irises were favoured for use in garlands. Centuries later, Dante uses wreaths of irises to adorn the twenty-four Elders who, in Purgatory, give him the promise of Paradise. The flowers represent the purity of the teachings of the Old Testament.

The flourishing city of Florence chose as its emblem the *Iris fiorentina* and, under Clovis I, the founder of the Frankish kingdom, the iris became a heraldic ornament. In some paintings of the Virgin Mary and the archangel Gabriel, in addition to the white lily—a symbol of the purity of the Mother of God—irises are also shown. Following the meaning given to them by the ancients, they signify the divine message and suffering that will pierce the soul like a sword.

The aromatic substances found in the rootstock of the iris have long been used in perfumery. Amulets carved from its rootstock were said to protect people and animals from evil spirits and magic. MH

left: flower and rootstock of an iris, 1828
right: Jan Breughel the Elder, *Small Bouquet of Flowers in Clay Vessel, c.* 1670

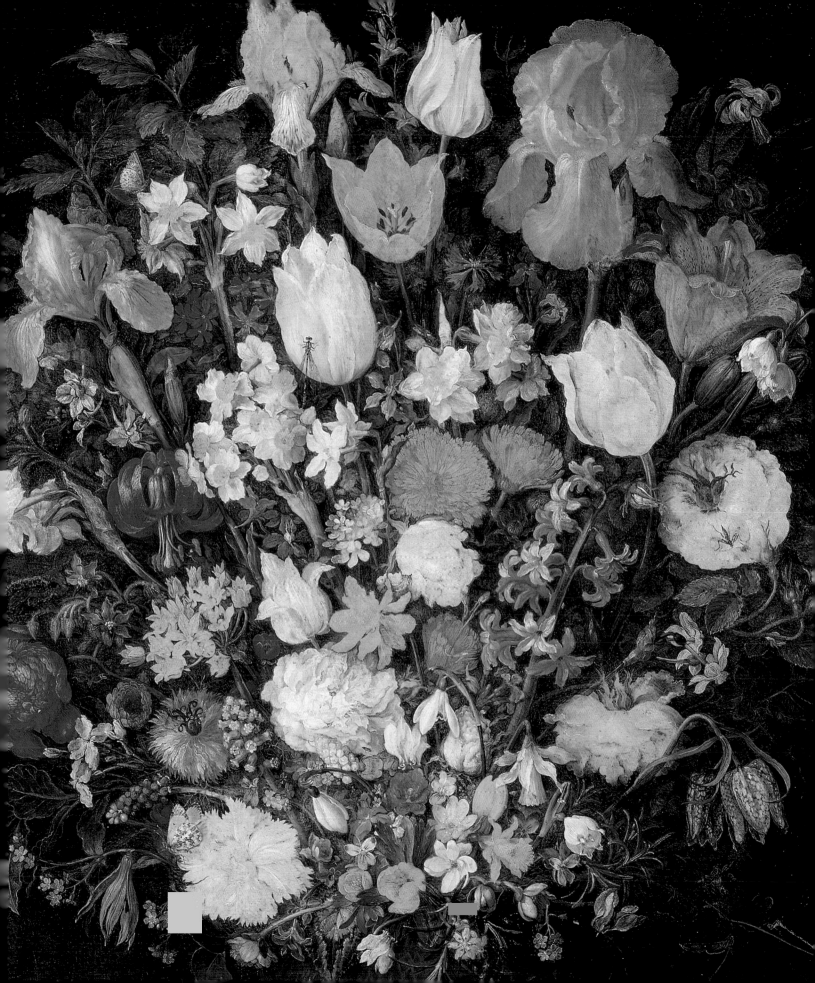

Lily

Lilium candidum

Purity; the supreme flower—exalted and unapproachable; strong religious symbolism; powerful fragrance

The impressive, white Madonna lily can reach a height of 1.50 metres and has beautiful, strongly fragrant flowers and a contrastingly plain foliage. Regarded as a reflection of pure light, its whiteness has frequently been taken as a symbol for surmounting earthly things and attributed with divine qualities.

The Greeks started this legend: according to them, white lilies were created from the milk of the mother of the gods, Hera. Hermes, the messenger of the gods, secretly fed the infant Heracles at the sleeping Hera's breast to give him immortality. The child suckled so forcefully that Hera—Juno to the Romans—awoke in pain and cast the child from her. Her milk continued to flow, however, and the Milky Way was formed in the heavens; here on earth, the lilies sprouted from the drops of divine milk, hence the name "Juno's roses". The lily and the rose were considered to be the supreme flowers, the former exalted and unapproachable, the latter soft and seductive.

Because Aphrodite, the goddess of love and roses, abhorred lilies for their undisguised purity, she gave them a pistil reminiscent of a phallus, or so the legend has it. In the *Song of Songs*, the beloved is described as "a lily among thorns". Roman Catholicism takes up these similes and makes the lily the symbol of Mary's 'immaculate concep-

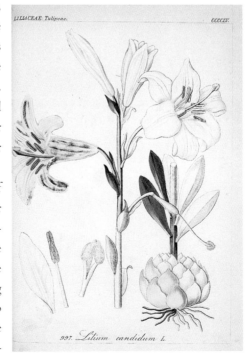

tion'. In very early paintings of the Annunciation, the angel Gabriel carries an olive branch, an ancient symbol of a messenger bringing good news; soon, however, the olive branch becomes a lily that is sometimes held in Gabriel's hand or seen in a vase placed in front of Mary. The lilies almost always have no pistils, and are sometimes shown even without any stamens. So much for Aphrodite's work!

The lily found its way into convent gardens and, together with the rose, iris and poppy, was among the flowers which, in 795, Charlemagne decreed should be found in gardens for medicinal purposes. Its flowers were frequently used to adorn pictures of the Virgin Mary and placed on graves as a symbol of the pure soul's resurrection. On account of their strong fragrance, lilies were favoured long ago as flowers for the dead. It was claimed that on the third day after a burial they would begin to grow of their own accord if the deceased had been an innocent person. Not until the era of Dutch still lives did painters dare to portray lilies in a more worldly way and to include them in elaborate flower arrangements. MH

left: flower and bulb of the Madonna lily, 1845
right: Balthasar van der Ast, *Still Life with Flowers and Fruits*, c. 1640/50

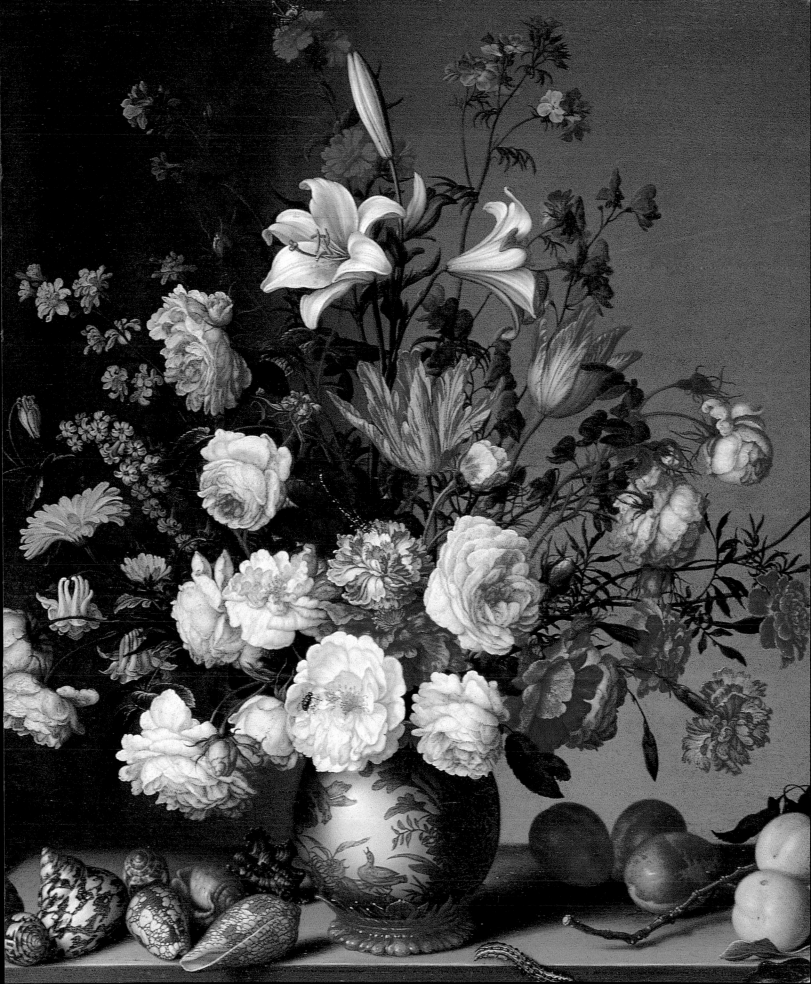

Lily of the Valley
Convallaria majalis

Fortune in love; poisonous yet with healing powers; a symbol of the Virgin Mary; making the right choice

The lily of the valley's attractive appearance is deceiving for it belies the fact that it is poisonous. Although the digitalis glycosides that it contains have long been used to treat heart complaints, the stalk of the flower and the berries can cause severe poisoning.

The flowers were used to obtain essences that formed the base of the much sought-after liquor "Aqua Aurea", that was considered to be an efficacious remedy for many complaints and which is said to be effective in treating the after-effects of strokes.

In the olden days, in both Britain and on the Continent, girls and boys would set out in search of lily of the valley in the month of May. Dances were frequently held at this time and the flower was reputed to bring good fortune in love. Lily of the valley comes into bloom after the violet and before the rose in the annual succession of beguilingly scented flowers and many a legend tells that the nightingale will sing only after the first lily of the valley has flowered.

As the lily of the valley was a northern European plant, there was no Latin or Greek name for it, so monks with knowledge of botany gave the lovely flower a Biblical name, *Lilium convallium*, Lily of the Valley. This name expressed, on the one hand, the flower's usual habitat on hillsides and in valleys, while on the other, it quoted the first lines of verse two of the *Song of*

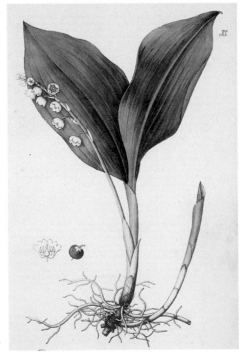

Songs: "I am the rose of Sharon, and the lily of the valley." Admittedly, this was a reference to the large lily, but the monks transferred the image of innocent charm to the small, native plant. Thus it became a symbol of the Virgin Mary and is seen in many mediaeval paintings at the Virgin's feet or in her hands. It was subsequently called the May lily or Mary's tear in Catholic regions, as it was said to have sprung from her tears at the foot of the Cross.

At one time, though, the lily of the valley was dedicated to the Germanic goddess of spring, Ostara. In her honour, spring bonfires were lit and the flowers of the lily of the valley were thrown into the flames as offerings.

Opposites such as good and evil, faith and heathenism, or deadly poison and healing powers became symbols for making the right choice. These are frequently encoded in mediaeval panels or later flower pictures where the struggle between the powers of good and evil is presented allegorically—but the lily of the valley always points in the right direction! MH

left: flower and fruit of the lily of the valley, 1833
right: Jacques de Gheyn, *Flowers in a Glass*, 1612

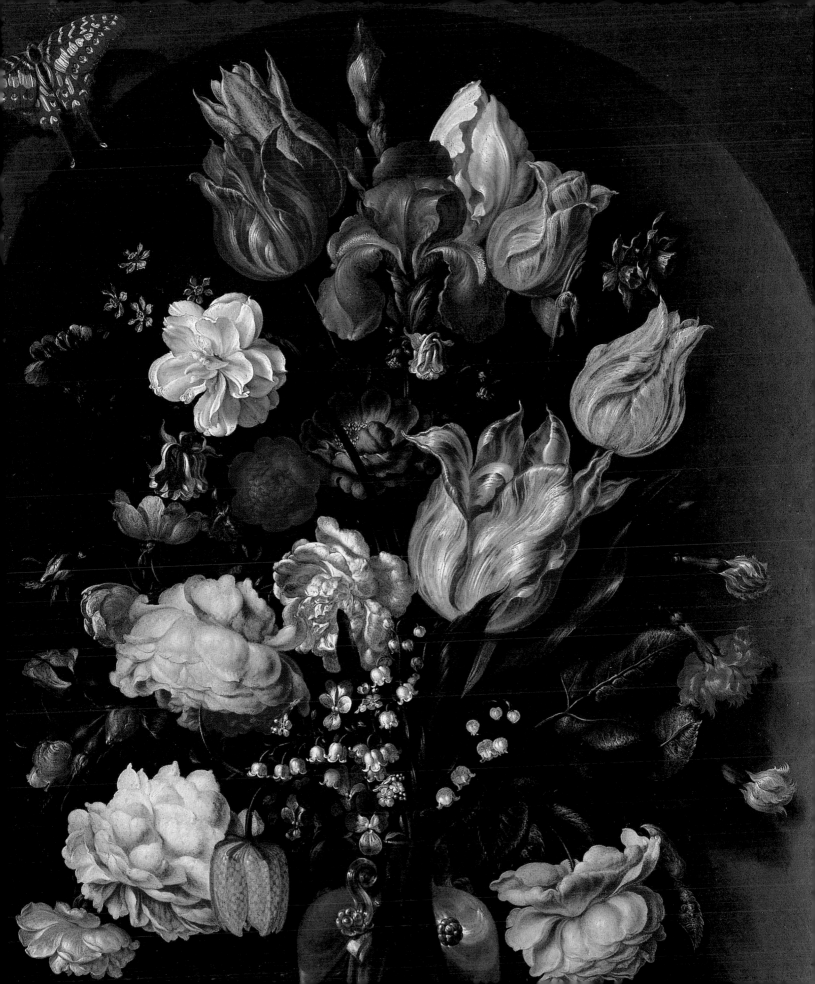

Love-in-a-mist

Nigella damascena

St Catherine's flower;
relieves muscular pains;
black seeds used as sedatives

In ancient times, the sight of this flower, enveloped by numerous, lace-like bracts, conjured up the picture of a young woman with loose hair. As its name implies, love-in-a-mist has strong romantic connotations—and in other cultures it is known by similar names such as "Maiden in the Country" or "Bride's Hair". Less romantically, love-in-a-mist is also called the fennel flower or devil-in-the-bush. These are just some of the popular names for *Nigella damascena*, whose Latin term is derived from the flower's black seeds (*nigellus*: black) and its Oriental provenance, being native to southern Europe, the Mediterranean countries and north Africa where it grows on the roadside and in fields.

In Christian iconography, nigella is the flower traditionally associated with St Catherine. Condemned to death at the order of Emperor Maxentius for her success in converting people to Christianity, the martyr was bound to a wheel and tortured. This is often depicted symbolically in paintings by the wheel-shaped nigella leaf.

Nigella has quite another side to it, though, too. If a young girl handed an admirer some love-in-a-mist, her message to him was to leave her alone. There were, in fact, a number of different flowers, nigella among them, that had unpleasant associations for country folk in centuries past. If they wanted to send someone packing, they simply placed these flowers in a covered basket that was dispatched to the unlucky recipient—and the message would have been perfectly clear.

Nigella, therefore, became a symbol of love, albeit mostly an unhappy one, and a symbol of unrequited love. Another reason for this association may be found in the insect world. A type of hinged lid shields the nectar from unwelcome guests. As a result, the sweet fluid can only be reached by more powerful creatures.

Country folk used to bake nigella seeds in their bread and use them as a tasty seasoning. In ancient times, the black seeds were used as painkillers and sedatives and so helped relieve muscular spasms. Wherever nigella grew in the wild, it was generally considered a weed, although a useful one, since the fumes from burning seeds kept vermin at bay and it was acknowledged as an effective protection against worms, fleas and gnats. However, since the sixteenth century, this hardy, annual garden plant of the buttercup family with its finely cut foliage and pretty blue or white flowers has become a favourite bedding plant—irrespective of its sacred, romantic or less attractive undertones.

SW

left: flower and fruit of love-in-a-mist, 1840
right: Osias Beert, *Basket of Flowers, c.* 1615

Mallow

Althea officinalis

A symbol for healing and forgiveness and of basic human foodstuffs; many medicinal uses; an aphrodisiac with magical powers

Mallows are among the oldest cultivated plants known to humans. Along with larkspur and acacias, the delicate petals of pink mallows were included in garlands bound by the Ancient Egyptians.

Every year on the island of Delos, the birthplace of Apollo, flowering and fruit-bearing mallow branches and asphodel roots were given as offerings to the god of light. As the most widely available and best means to stave off hunger and thirst, they were intended to symbolize the basic food-stuffs of humankind. The poor not only used the mallow as a source of food, but its seeds were considered an aphrodisiac and, allegedly, women's ills were also cured by them. Mallow and asphodel were planted on graves as food for the shadows of the underworld.

The fruit of the mallow resemble small cakes and tastes pleasantly sweet. Like the leaves of wood sorrel and sorrel, or the small leaves of the dead-nettle, the mallow fruit was frequently picked by children when playing out-doors. The stalks and flowers of the mallow contain substances that reduce inflammation, are effective expect-orants and can also help eye com-plaints.

The Bible tells the story of how Simeon regained his eyesight with the help of mallow extract and so was able to see the young Christ in the temple in Jerusalem. This story in St Luke's Gospel gave rise to a popular name for the mallow, "Simeon's root". According to Dioscorides, the Greek name *althea* is derived from *althaino*, meaning "to heal". The priestesses of Apollo are said to have smeared the soles of their feet with a paste prepared from mallows before walk-ing across hot coals in honour of the God. Mallows were found in the magical garden of Hecate, one of the goddess in Greek mythology of the underworld who was skilled in the art of healing. Several centuries later, Charlemagne ordered that mallows be cultivated in gardens as an important plant for the making of drugs. In fact, all parts of the mallow may be used for medicinal purposes: the flowers and leaves con-tain sugar, oil, starch and ethereal oils. Teething children even used to be given a piece of mallow root to ease their sore gums. Mallows with deep red, almost black flowers were thought to be especially curative and are the ones most often seen in botan-ical illustrations.

Whereas in Christian symbolism, mallows represent healing and, by ex-tension, resurrection, in the language of flowers in the nineteenth century, the mallow had become more a sign for asking forgiveness. MH

left: inflorescence of a mallow, 1828
right: Rachel Ruysch, A *Vase of Flowers on a Plinth*, 1701

Marigold
Calendula officinalis

Sun and fate; a reliable weather forecast; a love-potion but also a flower of the dead; medicinal qualities; used as a food dye

The marigold is widely found in Mediterranean countries and northern Europe. If its flowers fail to unfurl by seven o'clock in the morning, then rain can be expected—one weather forecast that can be depended on!

Its Latin name is *calendula* or small calendar, derived from the Roman word *calendae*, meaning the first day of the month. This came about because it was possible to tell the time of day by examining the flower. Its heads follow the course of the sun which is why the marigold is also known in some other languages as the "Sun's Bride". The marigold was popularly known as the "monk's head" in Germany because when all its petals had fallen off, what was left of the flower resembled a monk's tonsure.

"Marigold, comfort of the world, noble maid, help us towards salvation. Ave Maria," ran a fourteenth-century Dutch hymn that likened the marigold to the Virgin Mary, an association also reflected by the flower's popular name, "Mary's gold," which ultimately became marigold. The flower has another affinity to women: a girl was to drink a brew concocted from the marigold if her periods were irregular. At births, a perfume made of marigold leaves and flowers was said to aid the expulsion of the afterbirth.

Like the daisy and the marguerite, the marigold's petals could be plucked to find out whether "s/he loves me,

s/he loves me not". A piece of marigold root wrapped in purple cloth was said to be an effective love-spell.

The marigold has been a valued plant since the twelfth century and is found in all medicinal and country gardens. Apothecaries always had a supply of them and used the flowers to make lotions and teas. Calendula flowers have traditionally been considered beneficial for reducing inflammation, healing minor injuries and as an antiseptic. They have also been used to treat various skin diseases, ranging from skin ulcerations to eczema. The strong-smelling herb was used to "treat" cancer and, interestingly enough, research into the anticancer and antiviral properties of calendula is still being continued in the twenty-first century. On account of its bright yellow colour, it was also used as a food dye in the Middle Ages instead of expensive saffron.

In the nineteenth century, the marigold, representing the shining sun, became a symbol of life following its preordained path in the same way as the flower follows the sun. Yet the marigold, too, has another, opposite meaning: because of its strange smell, it is also known as the flower of the dead and is planted in graveyards. MH

left: inflorescence of a marigold, 1832
right: Ambrosius Bosschaert the Elder, *Flower Still Life*, 1614

Myrtle

Myrtis communis

On their expulsion from Paradise, Adam and Eve took a myrtle branch with them because of its delicious fragrance—at least according to one Arabian tale. The myrtle has heavenly origins in other countries, too, though: Athene killed a nymph called Myrsine who had dared to vie with the proud goddess in a contest of bravery and skill. Yet on seeing her opponent dead, Athene was overcome by grief and remorse and caused the myrtle to sprout from Myrsine's body, and the tears of the goddess made the myrtle's leaves evergreen.

While the myrtle found fame and acclaim in ancient Greece, its ties with its creator were eventually severed and instead it came to be associated with Aphrodite of Paphos for that is where the goddess of love first came ashore, concealing her great beauty behind a myrtle bush. The evergreen leaves, the delicate white flowers and the delightful scent transformed the myrtle into a symbol of beauty, youth and love—the perfect flower for a bride.

Aphrodite protected the myrtle, as she did marriage. Venus, her Roman equivalent, did so, too. Roman brides placed myrtle sprigs in their hair; bridegrooms held them in their hands. Yet marriage did not make the myrtle prudish: it also came to symbolize "forbidden" love in all its various forms and its presence was therefore forbidden on certain occassions.

In Ancient Greece members of the Athenian municipal authorities wore wreaths of myrtle as a symbol of their power and willingness to reach a mutual agreement and, when important announcements were proclaimed, the speaker would hold a myrtle branch in his hand. When the plague struck Athens in 431 BC, myrtle branches were burnt to create "healing flames" which, it was hoped, would help overcome the epidemic.

On the other hand, myrtle is also associated with death in certain instances. Whoever suffered the pain of unrequited love or had lost his life as a result of some driving passion, would be turned into a myrtle grove in the underworld. The myrtle was, therefore, always a symbol of love that endured beyond death. Perhaps the custom of placing a myrtle sprig in the grave of a deceased virgin was a promise of love in another world.

This custom was forbidden by the Christian church as it was felt to be heathen. Even though myrtle was later used to decorate churches for festive occasions, its use at weddings was long frowned upon. SW

left: flowering branch and fruit of the myrtle, 1840
right: Piero di Cosimo, *Venus, Mars and Amor,* c. 1505

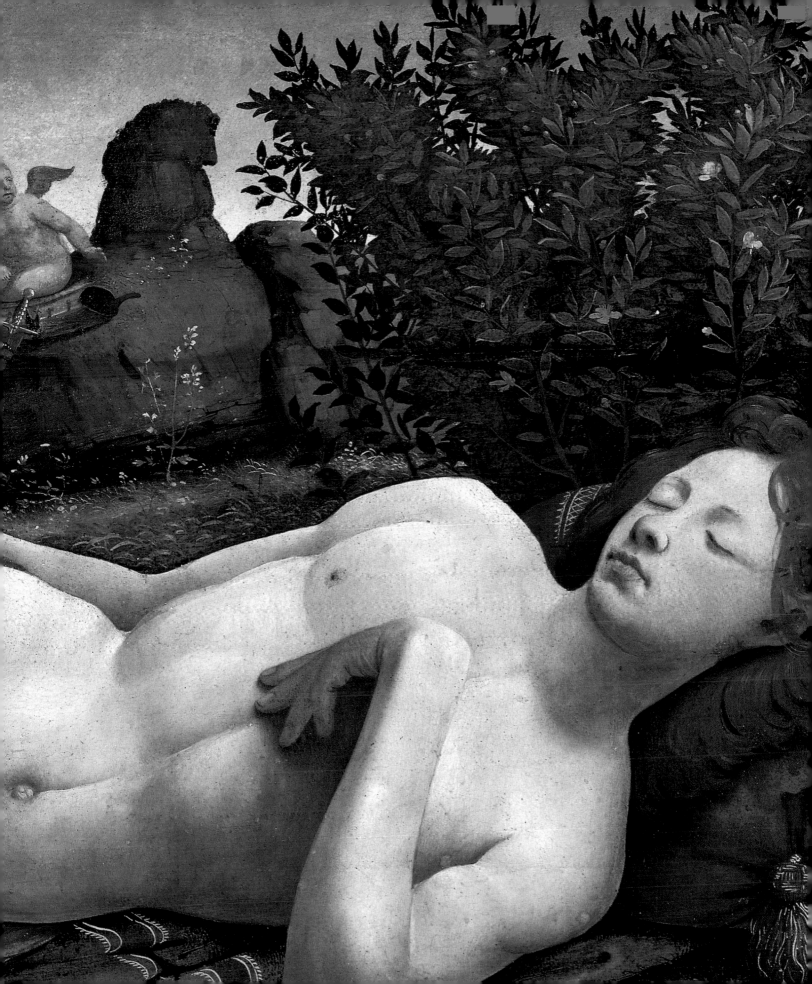

Oranges and Lemons

Citrus sinensis · Citrus limon

Flower and bear fruit simultaneously; citrus fruits symbolize paradise, immortality and eternal youth; purity and virtue; classic bridal accessory

The delightfully fragrant white flowers and the colourful fruit amid the evergreen leaves of citrus plants are a joy to behold. No other plant is so lovely and useful at one and the same time. Native to China, these plants had barely been introduced to the ancient world around the Mediterranean when they were already steeped in mythology and religion. The unusual ability of the citrus bushes and trees to flower and bear fruit simultaneously amid their dark-green foliage caused them to become symbols of Paradise, immortality and eternal youth.

In ancient Greece, they came to define all kinds of legendary golden apples. The wedding present of the earth mother Gaia to Zeus and Hera, a tree with "golden apples", was now thought of as a citrus tree. It was kept in the garden of the gods and was tended by the Hesperides and, because of its great value, was guarded by a giant serpent. It was one of the labours of Hercules to steal the fruit; this he did with the help of Atlas. Throughout antiquity, the Renaissance and the Baroque period, Hercules was portrayed carrying the fruit—a divine symbol of immortality and of a new golden age.

The reason why orange blossom is associated with the bride at a wedding in Mediterranean countries is due to its glorious scent and its white flowers that are symbols of virtue, chastity and

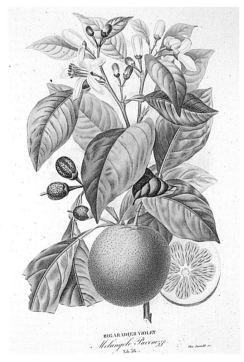

BIGARADIER VIOLET
Melangolo Pavonezzo
Tab 36.

innocence. In the Old Testament, the loveliest fruit from the loveliest tree is to be used as a decoration at feasts. At first, the cedar cone was thought to fit the description, but then citrus fruits assumed this role. Even Eve's apple from the tree of knowledge was interpreted as a citrus fruit. It is said that when she fled Paradise, she hid a lemon in her long hair and that is how we come to have at least one heavenly fruit here on Earth. Oranges and lemons later appeared in paintings of the Virgin Mary who rose above Eve and original sin, the citrus fruits being symbolic of her purity and virtue.

The sweet fragrance of the flowers symbolized the promise of love while the bitterness of the juice represented suffering and death (sweet oranges were not known until much later). In times of plague, lemons were said to offer protection against infection and sickness. This symbol was, in fact, maintained right up until the twentieth century in some parts of Europe where expensive fragrant lemons would be carried by mourners on their way to the graveyard. They were spiked with cloves or decorated with rosemary sprigs as a sign of eternal life. MH

left: flower and fruit of the bitter orange, 1820

right: Francisco de Zurbáran, *Still Life with Lemons, Oranges and a Rose*, 1633

Pansy

Viola tricolor

Sign of holy trinity; symbolizes loyalty; a remedy for epilepsy; prevents cramp; strengthens the powers of the memory

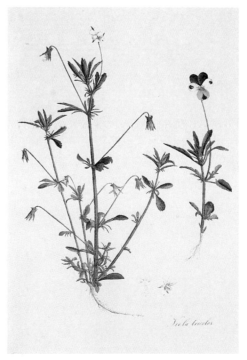

The pansy with its tricoloured flowers is one of the most mysterious of plants. In Christian symbolism, an eye surrounded by a collar of radiating light was a sign of the holy trinity and the lines of colour in the pansy's petals were seen as a reference to this. As a result the pansy acquired considerable religious significance. Wild pansies—which also enjoy the names johnny-jump-up, heartsease and love-in-idleness—mostly have yellow, white and blue flowers.

The pansy has long been said to possess special powers. In Shakespeare's *A Midsummer Night's Dream* Oberon pours the drops from a pansy's stalk onto the sleeping Titania's eyelids. As he explains to Puck:

> Yet mark'd I where the bolt of Cupid fell:
> It fell upon a little western flower,
> Before milk-white, now purple with love's
> wound,
> And maidens call it love-in-idleness.
> Fetch me that flower; the herb I shew'd thee
> once.
> The juice of it on sleeping eye-lids laid
> Will make a man or woman madly dote
> Upon the next living creature that it sees.

The trick, however, did not quite work to plan!

In many European countries, the pansy was long considered to be a sign of loyalty. Engaged couples would present their partners with portraits of themselves surrounded by garlands of pansies. No poetry book was complete without the pansy. Similarly, on the first Sunday after Whit, Trinity Sunday, a pansy used to be worn in a buttonhole at church services.

Hardly any other flower has made the transformation from unprepossessing weed to such magnificence as the pansy. After 1810 or thereabouts, the pansy was all the rage in Britain, with one grower trying to outdo the other. It was cultivated in an endless variety of forms in English gardens. The shape of its flowers was originally long and narrow, but over the centuries it has become almost round and has acquired the shape now so familiar today with its pretty, face-like markings.

Infusions made from the leaves of the pansy have been prescribed since the Middle Ages as a remedy for epilepsy and to prevent cramp. The pansy's sap was also said to cleanse the blood and strengthen the powers of the memory as well as having anti-inflammatory properties. *Viola tricolor* is a highly regarded treatment for skin disorders like eczema, rashes and itching. The flowers especially are considered beneficial for diseases of the heart which is reflected in one of its other names, heartsease. MH

left: inflorescences of the wild pansy, 1828
right: Henri Fantin-Latour, *Still Life with Pansies*, 1874

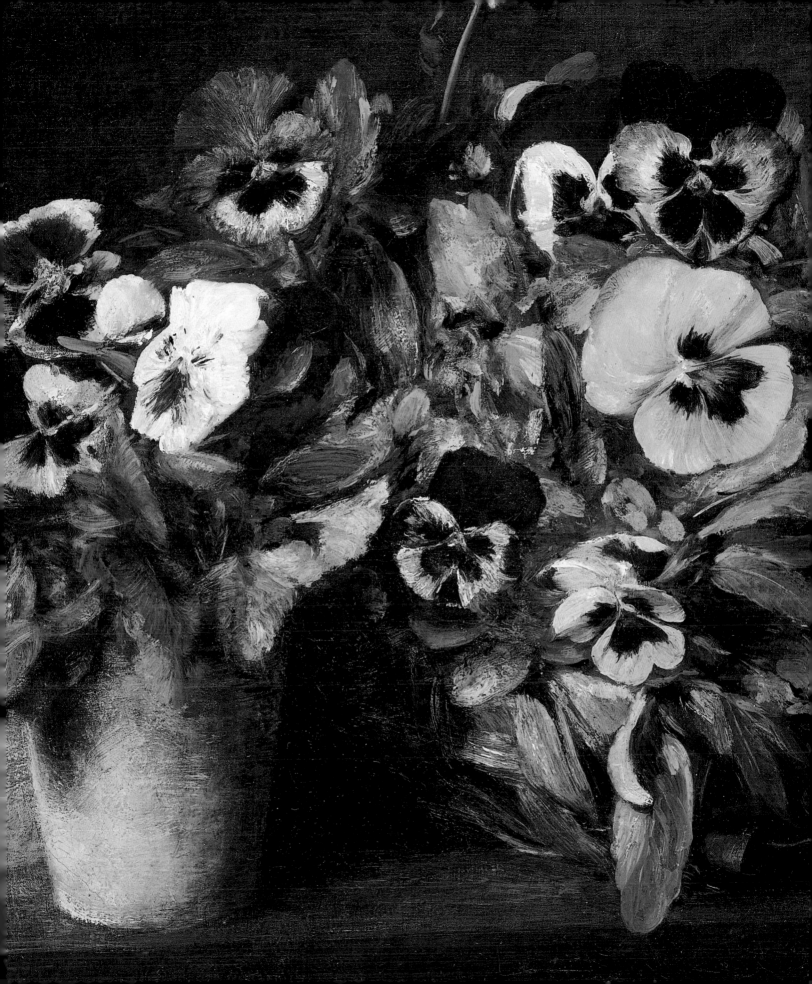

Passion Flower

Passiflora coerulea

Powerful symbol of the suffering of Christ, faith and suffering, but also of primeval nature; yearning for a long-lost paradise

The passion flower is native to the jungles of Brazil and Peru. Its Latin name is made up of *passio*, suffering, and *flos*, flower—and there are few other plants whose symbolism and attributes have been forced on it like the passion flower. Amid the vastness of the tropical rainforests, it wound its way up the trunks of the giant trees and produced countless strange-looking and fascinating flowers. When the Spanish arrived to crush the Inca empire in the sixteenth century, they discovered the passion flower and saw in it a sign of "divine approval" for their ruthless and destructive campaign. For them, the flower proved that the destruction of the Inca culture had been preordained and sanctioned by God. The innocent plant was thus declared the "flowering apostle", symbolizing the conversion of South America to Catholicism.

Spanish monks returned to the Rome of Pius V in 1568 with the passion flower which, in 1633, was described by the Jesuit Giovanni Battista Ferrari—a man well versed in botany and the author of a number of magnificent books on flowers—as follows: "This flower is a miracle for all time, for in it, God's own hand has portrayed the suffering of Christ. The corona ends in thorns reminiscent of Christ's crown of thorns; the Saviour's innocence is reflected in the flower's white colour; the ragged nectary is reminiscent of his torn clothes; the styles represent the nails that were driven through his hands and feet; the five stamens represent his five wounds; the tendrils represent the whips."

Thanks to its own poetic appeal, the flower was able to shake off such heavy religious symbolism. Between 1799 and 1804, the German naturalist and explorer Alexander von Humboldt travelled through South America and enthusiastically described the tropical jungle home of the passion flower which achieved new fame as a result. Passion flowers were grown in the gardens of the Empress Josephine in Paris and, in the fashionable language of flowers of the day, came to symbolize faith and suffering, but also primeval nature. They have this ambiguous meaning in the painting shown here where they are seen growing all over the grave of Julie d'Angennes.

As a symbol of hankering for a long-lost paradise, the passion flower is often seen in depictions of gardens from the classical period entwining itself around bowers and adorns wallpaper hanging in many country houses and palaces. MH

left: blue passion flower, 1787
right: Jan Frans van Dael, *Tomb of Julie*, 1803/04

D M.
FLOS IPSA IULIA SICUT
FLORES PERIIT

Peony
Paeonia officinalis

Luminous flowers, healing roots, phosphorous seeds; mystical and magical powers; an ardent love of God

The peony is one of the most voluminous of European flowers. Its bright red, round flowers add the finishing touch to many sixteenth and seventeenth-century paintings. The peony, shortly thereafter, was moved from the medicinal plant section of convent gardens to ornamental and country gardens.

Throughout antiquity, it was associated with Apollo, the god of light, who had passed in on to Paeon, the physician of the gods—after whom the flower takes its scientific name. Paeon is said to have recognised the healing powers of its roots and seeds and even to have used them to cure Hades, the god of the underworld. The peony, then, with its luminous flowers and healing roots, unites the forces of dark and light.

Many of the flower's early names betray its connection with the moon and the night. It roots were said to possess magical healing powers only if they were unearthed by moonlight. Those in search of peony roots during the day—as related in legends of old—had to contend with the wood-pecker which would peck out the eyes of anyone attempting to uproot the flower. The bright red seeds were also collected at night time when a faint glow caused by phosphorescent substances in them meant they were easier to find; it was, of course, understood as a sign of especially potent magic powers.

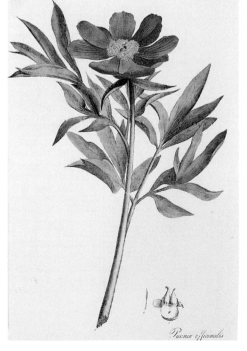

Paeonia officinalis

Roots used to be hung around the neck to protect the wearer against disease; the glowing seeds, likewise, were made into necklaces to ward off evil spirits and to prevent cramp. Substances in the peony's roots increase the need to pass water and so really do relieve gout, while an alkaloid present in the roots has blood-cleansing properties. As a plant with mystical powers, the peony was traditionally among the show of flowers seen in illustrations of Paradise. Although its healing powers were originally associated with the Greek gods, Christian symbolism transferred them to Christ. A "rose without thorns", the peony became one of the main flowers associated with the cult of the Virgin Mary; in May, with its many festivals, it was used as an altar decoration in her honour. With its red flowers, the peony became a symbol of an ardent love of God.

In the eighteenth century, when chinoiserie was all the rage, Chinese shrub peonies made their way to Europe and proved a serious rival to the European peony. MH

left: flower of a single peony, 1828
right: Ambrosius Bosschaert the Elder, *Bouquet of Flowers, c.* 1610

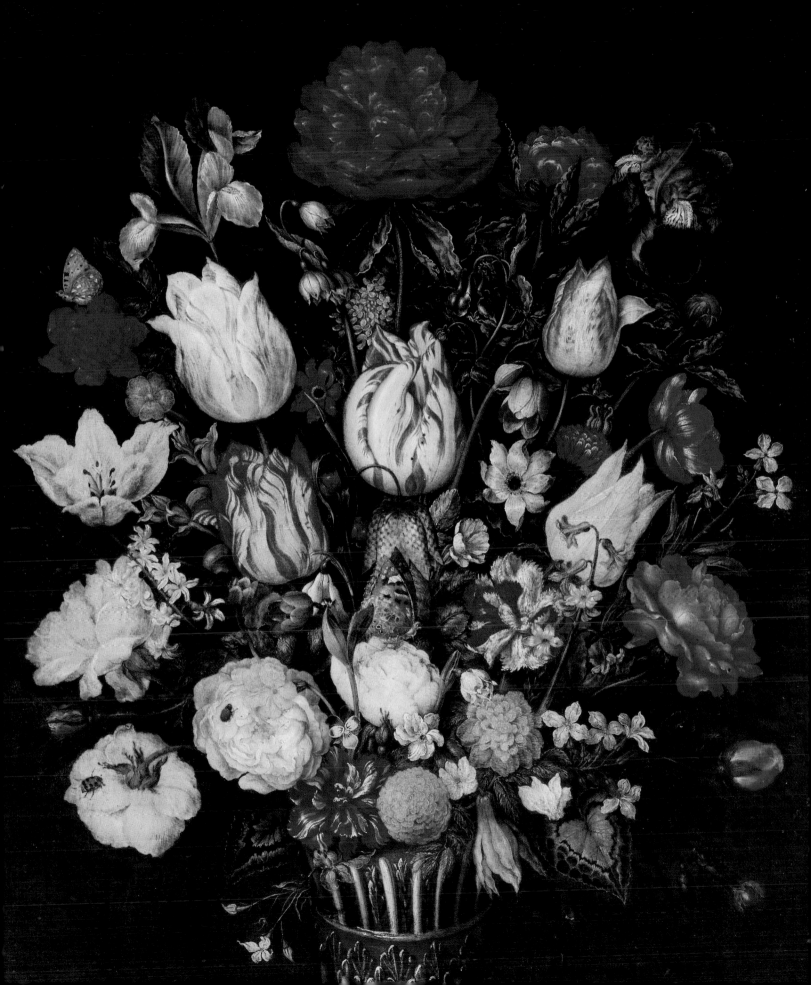

Pomegranate

Punica granatum

Sensuous love and passion, fertility and immortality; intellectual ability and creative power; a symbol of compassion; an aphrodisiac

Nowadays a dash of grenadine in a cocktail is all that remains of a once powerful symbol—a symbol of diversity in unity, of immortality and lasting fertility. But above all else Aphrodite's favourite tree, first planted by her in Cyprus, is a symbol of sensual love and passion. The oldest evidence of the pomegranate is found on a Mesopotamian ritual vase from the fourth millennium BC in a temple dedicated to Astarte, later known in other cultures as Isis, Venus—and Aphrodite. The goddess of love and seduction is always surrounded by pomegranates, as is also the case with Hermes and pleasure-loving Dionysus. In Syria, the pomegranate shared the same name as the Sun God, Hadad Rimmon, the god of procreation and an animating force. When the fruit bursts open, the "crowned apple" reveals its many seeds that represent numerous progeny—a sign of hope and rebirth.

Pomegranate blossoms were woven into the necklaces of many high-ranking Egyptians before they were buried. The blossoms were scarlet, but unlike the fruit itself, they had little significance. The ancient Egyptians made a wine from pomegranate seeds, too, that hardly surprisingly, was said to have aphrodisiacal qualities. *Punica granatum*, the Punic apple, was cultivated in early Egypt and Palestine, and even reached China in the second millennium BC, early enough to allow a rich symbolism to develop around it. As a fertility

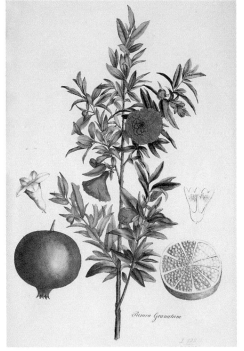

Punica Granatum

symbol, it was essential at weddings, but its fruit was regarded as so seductive that its use at ritual sacrifices was forbidden.

The pomegranate was even more revered in Judea: it was permitted in the Holy of Holies and was even allowed to decorate the Ark of the Covenant. The holy apple represented God's commandments as a whole, was a symbol of the law and was used to adorn priests' robes. The "apple of apples" was now not only exclusively a symbol of sensuous love, fertility and procreativity, but also of intellectual ability and creative power. In Christian symbolism, the pomegranate was stripped of its sensuous associations and became a symbol of compassion for others. It represented the many virtues of the Virgin Mary, but also the communion of the faithful under the protection of the Church.

But back to worldly matters: the Punic apple's red colour, associated with blood, love and war, is also the colour of power. The fruit's shape, with it crown-like calyx, made it an ideal imperial orb. The Moorish sultans of Granada used the pomegranate as a royal symbol and Henry IV of England (1367–1413) incorporated it into his coat of arms. sw

left: flower and fruit of the pomegranate tree, 1828
right: Jan Davidsz de Heem, *Fruit and Flower Cartouche with Wine Glass*, 1651

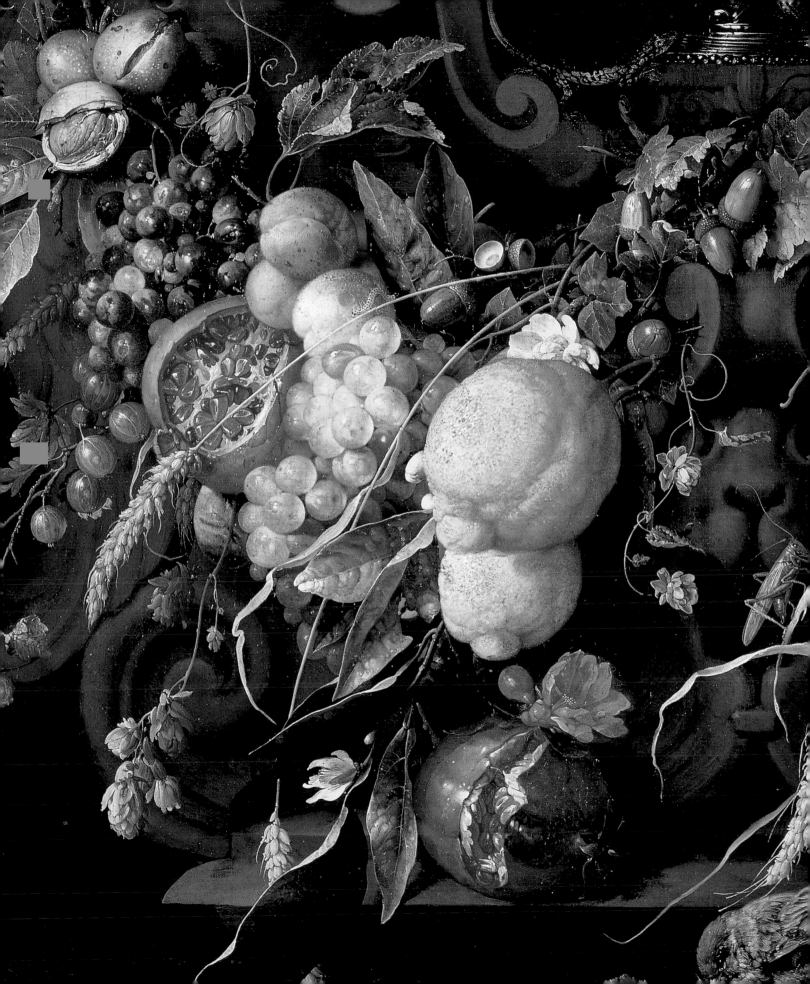

Poppy

Papaver rhoeas · Papaver somniferum

Magical flower; represents life and death, good and evil, light and darkness; fruitfulness

The poppy unites heaven and hell, abundance and dearth, life and death. Such diametrically opposed qualities greatly attracted still life painters and their clients in the seventeenth century. The poppy's message to the attentive viewer was: "Know that life is illusory; set no store by outward appearances. Lead a righteous life. Do not be captivated by my short-lived beauty for within me lie the seeds of death and oblivion."

In Jan de Heem's still life, the white carnation is the antithesis of the red poppy and symbolizes the contrast between an unthinking life given over to superficial pleasures and a life consciously led in the example of Christ.

The red corn poppy grows in summer fields. It needs tilled earth to become established and so is found wherever the soil has been cultivated. Christians during the Middle Ages saw a symbol of the Sacrifice of the Mass, the Eucharist and of Christ's passion in the close association between ripe ears of corn and red poppies.

The opium poppy, *Papaver somniferum*, was associated in Greek mythology with several gods corresponding to its different qualities. Demeter, the goddess of fertility and agriculture, wore poppy flowers and seeds as did Morpheus, the god of sleep and dreams, and Hypnos, the god of sleep. All goddesses associated with love and fruitfulness, from Aphrodite

to Hera, held poppy seed capsules, the most fitting symbol of fruitfulness and wealth.

All parts of the opium poppy contain a white narcotic fluid which is purest in the seeds. Unripe capsules must be scored in the evening so that their latex can be collected the following morning.

In Great Britain, poppies are a symbol of the men who died among the poppy fields of Flanders during World War I. Every November, paper poppies are sold for the benefit of charities caring for veterans and poppy wreaths are laid at war memorials throughout the country on Remembrance Sunday. Interestingly enough, even back at the time when Homer wrote the *Iliad* in the ninth or eighth century BC, there is already a description of a dying warrior whose head sinks like a poppy flower.

The poppy has always been seen a magical flower suspended between good and evil, light and darkness, healing and annihilation. MH

left: flower and multiple fruit of the opium poppy, 1828
right: Jan Davidsz de Heem, *Bouquet of Flowers in a Glass Vase*, c. 1640

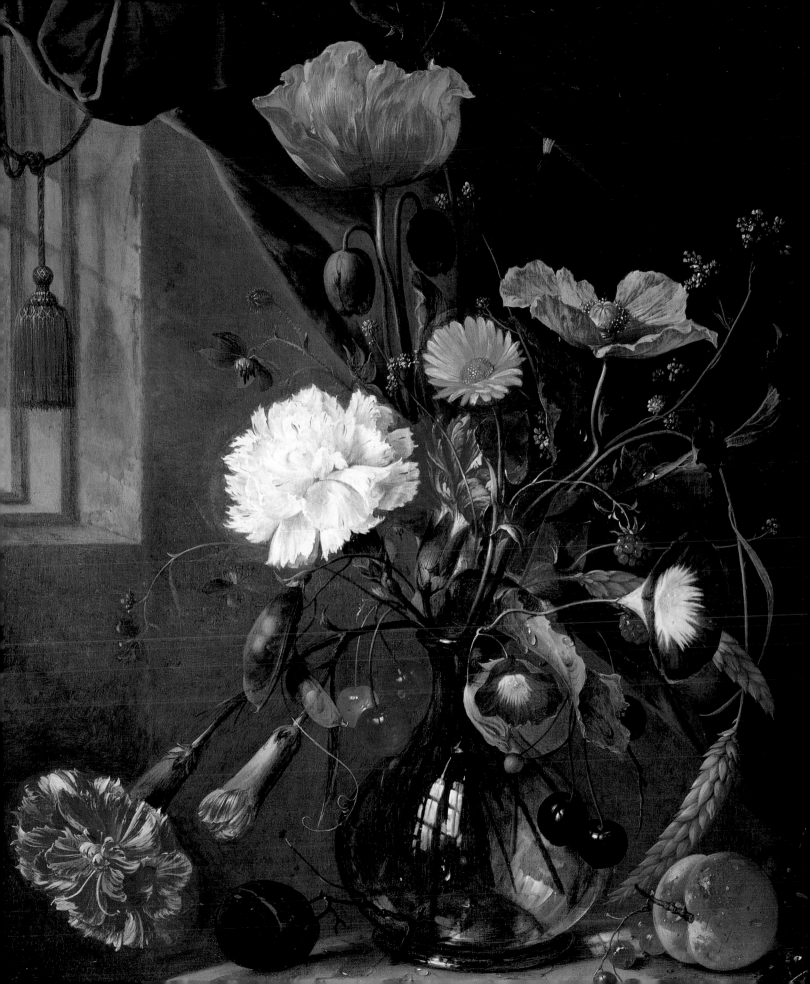

Primula

Primula veris · Primula auricula

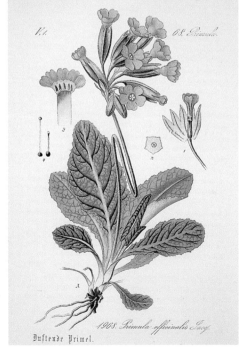

Primula veris, the yellow cowslip or primrose, is one of the first flowers to mark the arrival of spring in central Europe and to herald a new year in the floral calendar. Its early flowering is expressed in its Latin name, *primula*, literally the small and first one, an affectionate botanical name. Celtic druids knew they had to collect the first cowslips while sober and in their bare feet, otherwise the flowers would lose their healing powers. In folk tales in central Europe, the cowslip or primrose is the mysterious flower that points the way to hidden treasure and is the key to unlock castles. Its magic powers are said to be especially strong when it flowers very early in the year. It was in fact believed that if a young lady came across a primrose in the fields before Easter, she would be married that very year.

In Catholic symbolism, the primrose has been described as "light-suffusing" since the fourteenth century—a universal flower found along the path of mercy. If a sinner passes it by, the "flower of compassion" will assist him and save his soul. Mary is described as the root from which the triumphant primrose grows that holds the key to heaven. This interpretation made the flower a symbol of Christ's resurrection. In the Middle Ages, the purity of souls in heaven was symbolized in the form of wreaths of cowslip or primrose.

By contrast, for Shakespeare the primrose was a symbol of frivolity and thoughtlessness. "I had thought to have let in some of all professions that go the primrose way to the everlasting bonfire," says the porter in *Macbeth*.

In the seventeenth century, English gardeners succeeded in crossing *Primula veris* and *Primula auricula*, two primula species native to Europe. Their efforts gave rise to the gaily-coloured garden primulas that went on to conquer the hearts of gardeners everywhere. It has a variety of colours barely matched by any other flower, extending from pale yellow to the deepest purple. Its spherical flower heads could be effectively combined with the graceful single flowers of other plants. In the early eighteenth century, large stands were built that allowed proud growers to show off their tiered collection of auriculas to their visitors. It was not only gardeners, but painters, too, who developed a passion for the new variety, adding the primrose's spherical flowers in their still lifes.

In the language of flowers, the primula expresses contentment and pleasure. MH

left: scented primrose, 1840
right: Jan van Huysum, *Bouquet of Flowers in front of a Park Landscape*, c. 1730

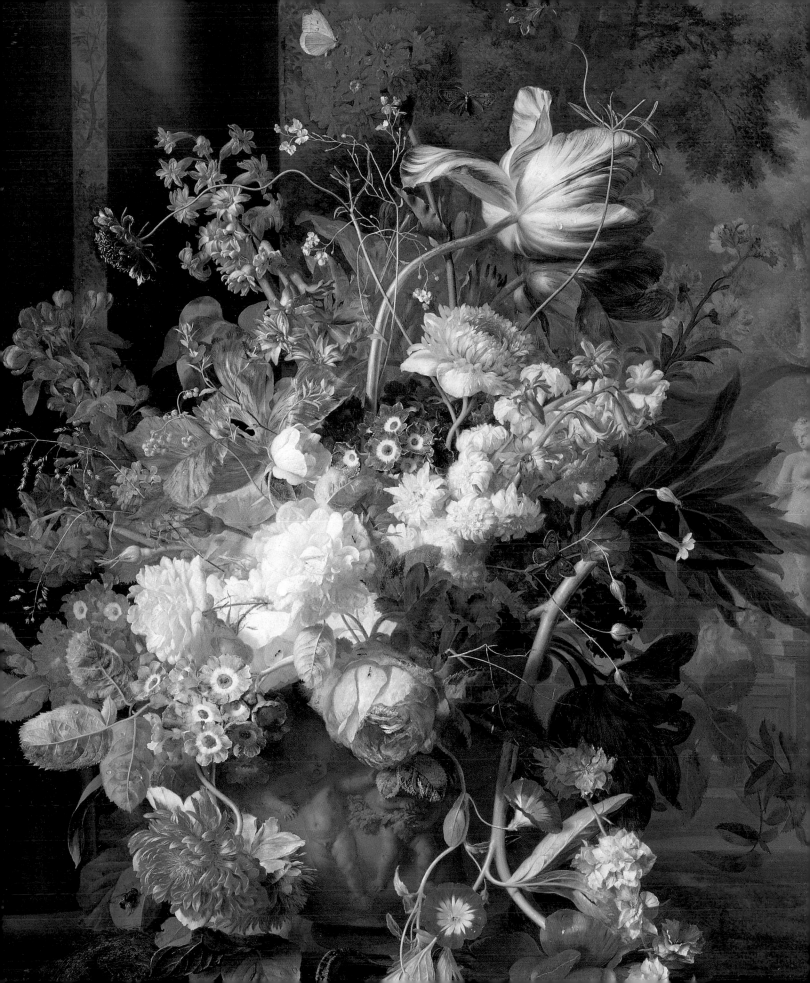

Rose
Rosa gallica

Love and joy; a paragon of virtue;
beauty and fragrance; the queen of
flowers; used to treat headaches,
hysteria and other complaints

Was the rose born of Amor's smile or did it fall from the hair of Aurora, the goddess of dawn? Or was it fashioned by Cybele, the Roman goddess of nature, when seeking revenge on Venus, the goddess of love, whose beauty could be surpassed only by a single rose?

Beauty, durability and fragrance have made the rose a symbol of love. No other flower has been so admired or has inspired so many poems as the queen of flowers.

In her love nest, Cleopatra had pillows filled with rose petals. The Romans used roses for decorative garlands and wreaths at their lively feasts and Nero had rose petals shower down upon his guests. Garlanded with roses, adolescents approached the Council of Elders—and garlanded with roses they went into battle, too. The rose is, however, also a symbol of death. According to a Jewish legend, it takes its colour from the first blood spilled on Earth. The wild rose of the Teutons symbolized the underworld, battle and death. They named their battlefields rose gardens and it was there that those who had died in battle found their final resting place.

To the first Christians, the rose, the epitome of Roman decadence, was something shameful. However, the rose and people's love of it were stronger. The mysterious flower came to be dedicated to the Virgin Mary and *Rosa*

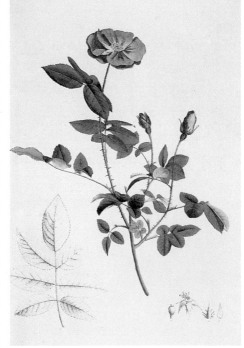

mystica became Mary herself. Red roses symbolized Mary's suffering, white roses her joy; and virgins devoted to God were given the name Rose. The flower that symbolized enjoyment of the pleasures of life had become a paragon of virtue. As ever, there were exceptions: in Nîmes, as late as the nineteenth century, prostitutes were known as "roses". And whatever one was up to, it could always be done *sub rosa*, be it the exchange of a sweet secret or an item of political or military importance. When the Greeks were planning their decisive battle against the Persian king Xerxes, they did so under strict secrecy in a rose bower—*sub rosa*. A widespread custom during the sixteenth and seventeenth centuries was to paint roses on the ceilings of council chambers and meeting places.

The rose, the national emblem of England, was known in ancient India; Confucius mentions a rose garden in Beijing; and Columbus found it in the New World. In the sixteenth century, the Provençal rose was sometimes confused with the Provins rose, the *Rosa gallica*, an indigenous central European plant. *Rosa gallica officinalis*, the apothecary's rose, was used to treat headaches, hysteria and numerous other complaints. SW

left: Provins Rose, 1828
right: Antoine Berjon, *Still Life with Flowers, Shells, a Shark Head and Fossils*, 1819

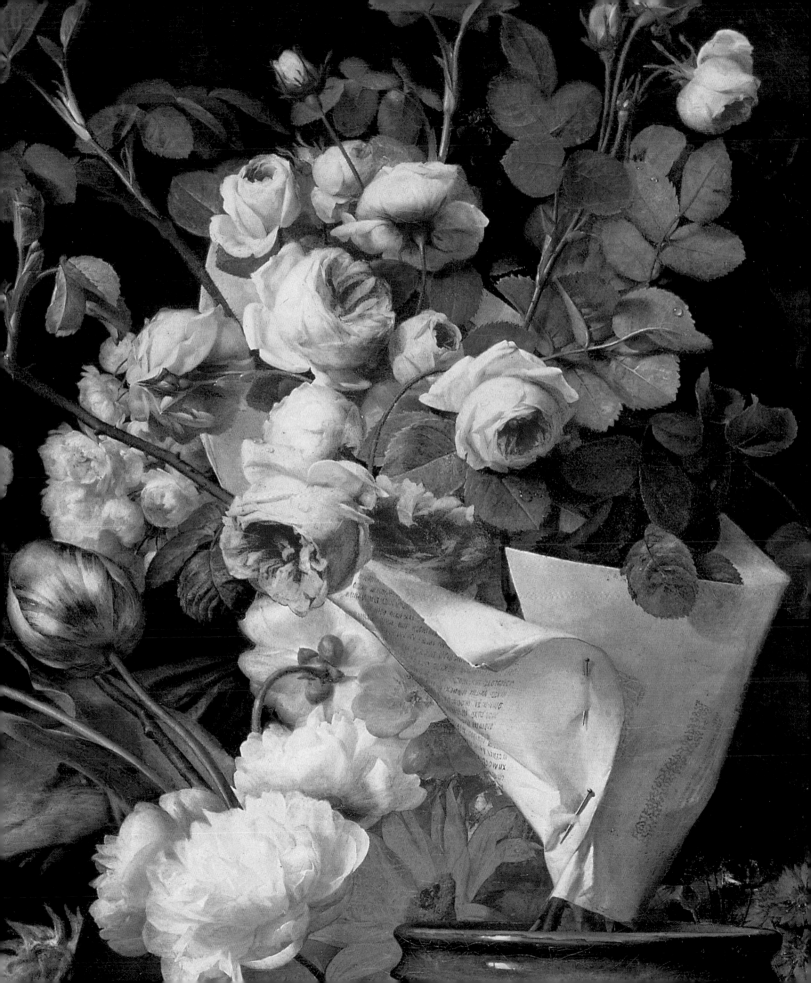

Rosemary
Rosmarinus officinalis

Strongly aromatic; invigorating, relaxing, aids the memory; associated with love and vitality, but also death

You can almost hear the sound of the waves in the name *Ros marinus*, a poetic name that was given to rosemary possibly because of the sea-blue flowers that blossom in spring, covering the parent bushes which can reach two metres in height. On the other hand, it may have been so named because it drew the Mediterranean seafarers of old back home: even before they sighted land, they could smell the rosemary's spicy fragrance that wafted across the water to them from the shore. Rosemary was a gift from Aphrodite, the goddess of love and beauty who was born of the sea and who first stepped ashore on Cyprus.

Rosemary, along with other fragrant herbs, was burned at altars to thank the gods for their beneficence or to placate them if they were angry. As a medicinal plant, rosemary was said to cure jaundice, a view held by Discorides, the famous ancient Greek physician and pharmacologist (1st century AD). But rosemary was far more important as a flower used in wreaths, an invention of Dionysus, the god of wine. Floral wreaths were central to cultish practices, and were initially reserved for the gods. Priests later allowed ordinary worshippers, too, to use them and even sacrificial beasts crossed the great divide with floral wreaths around their necks.

As Aphrodite's gift, the evergreen and strongly aromatic rosemary was associated with love. It was also said to be of great use in aiding the memory, which goes to explain why young ladies gave their sweethearts a rosemary sprig as a reminder of them when they parted. "There's rosemary, that's for remembrance" as Ophelia urges in Shakespeare's *Hamlet*. The Romans appreciated rosemary's qualities and believed that it could inspire thoughts and raise self-esteem. Rosemary's invigorating and relaxing effects are widely recognised, in fact. Better not to dream of rosemary, however, because—as legend has it—it represents the death of a loved-one. "Last night I dreamt a dream, / As black as black could be, / There grew outside my window / A tree of rosemary." Like many other plants associated with vitality and life, rosemary therefore also has connotations of death, but in the hope of a reunion.

As a symbol of unwavering devotion, rosemary was an absolute must at weddings and was frequently chosen by brides for their bouquets. When Anne of Cleves became the fourth wife of Henry VIII, she wore a crown of rosemary, hoping—in vain—that the popular saying "a bride's bouquet of rosemary makes love evergreen" would hold true. SW

Rosmarinus officinalis

left: inflorescence of the rosemary plant, 1840
right: Isaak Soreau (?), *Still Life with Flowers, Fruits, Wine Glass and Vase of Flowers, c.* 1620

Stock

Matthiola incana

Everlasting beauty; a symbol of a happy life and a contented existence; changeable, unpredictable

Like so many other flowers, stock, too, can trace its roots back to an Olympian love story. Zeus was smitten by the beautiful Princess Io which made his wife, Hera, very jealous. The love-sick Zeus therefore decided to hide Io by transforming her into a magnificent white animal and determined that she would graze among flowers. Gaia, the goddess of the earth, helped him in his plan and let stock and violets grow in the fragrant meadow to provide nourishment for Zeus's beloved.

The Greek philosopher Theophrastus recommended using "white violet", or stock, due to its spicy fragrance, along with roses, as the flowers of choice when putting a bouquet together. "Viola" for most Romans could be both the violet and stock. Despite this recommendation, there were a few people—the poets Horace and Martial, for instance— who did not hold stock in very high esteem. The poets bemoaned the extravagance that flowers occasioned. Where useful plants once grew, now only "perfumed violets" and stock were to be found smothering everything else.

In the Middle Ages, stock regained its popularity, especially in the homes of the ruling classes. The mistress of a castle would have had large amounts of it grown in her gardens as it was considered to be a symbol of everlasting beauty. It is said stock was so well tended that individual flowers were as large as small roses. Yet stock went the

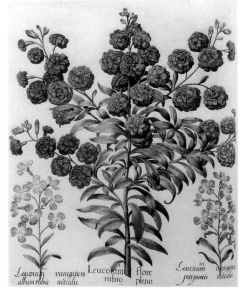

same way as the cornflower and ended up fighting for its reputation because it sometimes changes the colour of its leaves and this gave rise to the name "mutabilis", meaning changeable or unpredictable. Nevertheless, stock was hugely popular in private and convent gardens, especially in Italy where, as the *fior di pasqua*, it was used for Easter decorations, possibly because of its pure white colour. In conjunction with yellow, it made up the colours of Catholic Easter celebrations.

Stock has been known as *Matthiola* only since the eighteenth century when it was named after the famous Italian botanist and author of books on herbs, Pierandrea Mattioli, who lived in the sixteenth century. The genus *Matthiola* includes some fifty species of annual and perennial herbs. Stock's specific epithet, *incana*, means "hoary" and refers to the plant's typically fuzzy stem.

While several different regions had their own name for the flower, in poetry it always had the same meaning and was a symbol of a happy life and a contented existence. sw

left: white and violet stock, 1613
right: Jacques Linard, *Bouquet of Flowers*, early 17th century

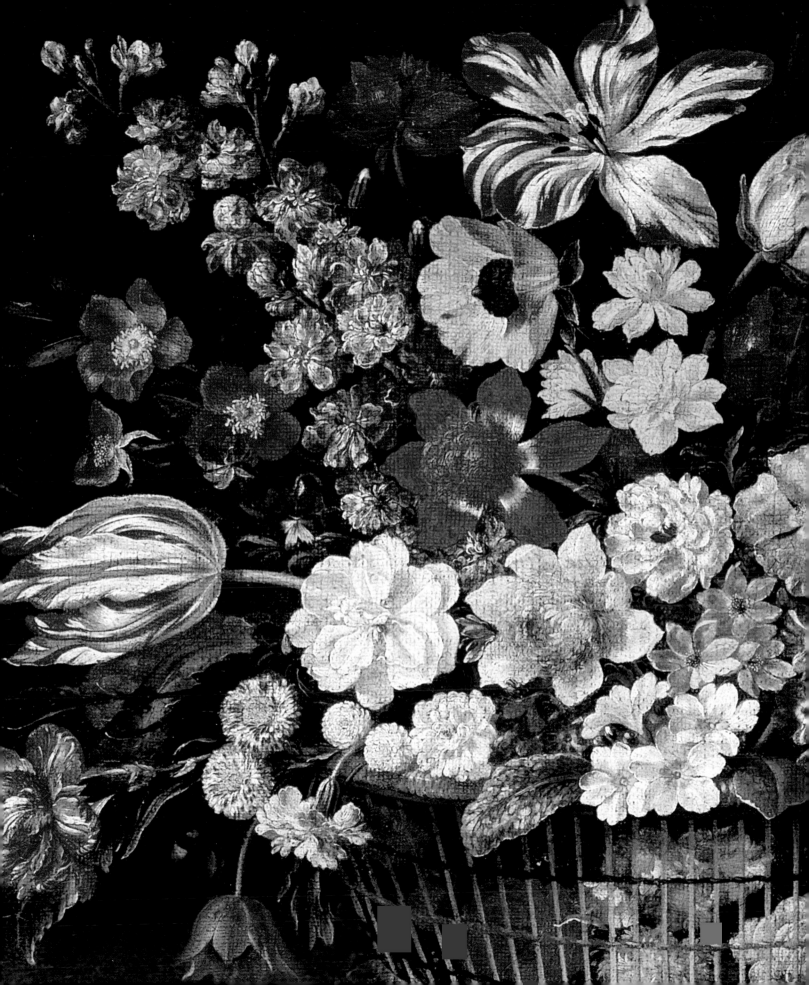

Strawberry

Fragaria vesca

First fruit of the year; a symbol of purity and sensuality, fertility and abundance, humility and modesty

Fraga vesca, the delicately fragrant ones, was the name given by Pliny and Virgil to wild strawberries. This plant was first mentioned in Roman times and the poet Ovid describes wild strawberries in his *Metamorphoses* as the fruit of a Golden Age when food grew effortlessly in Elysian fields. In later Christian explanations of nature they came to be seen as a typical fruit from heaven.

In paintings, strawberries, together with violets and marguerites, are frequently found at the feet of the Virgin Mary, Christ and the Saints where they represent humility and modesty. The fruit's attractive compound leaves, with three leaflets, were regarded as a heavenly sign and a symbol of the Holy Trinity. The white flowers stood for purity and chastity and, when in blossom, were associated with the Annunciation and Incarnation.

The red fruit, with no thorns, skin or pips, is the first fruit of the year and came to symbolise the virtuosity of those who accomplish good deeds with humility.

Sun-ripened fruit would have been understood as a symbol of spiritual growth. It was an allusion to sensuality and eroticism, to fertility and abundance—as well as being symbolic of the fruits of the spirit, the fruits of good deeds, the fruits of the heart, and of physical and spiritual love. Again there is a strong interplay with symbols

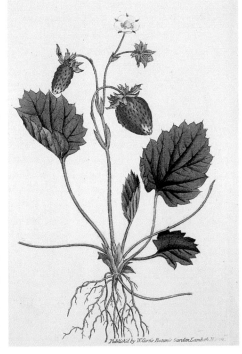

that can be variously interpreted: positively and negatively, spiritually and materially or sometimes both—intellectually toying with meanings from the sacred to the profane which, at the start of the nineteenth century, were often given fantastic interpretations.

According to one legend, women mourning the death of a child were not allowed to eat strawberries before Midsummer's Day. On that day, the Mother of God would take the children in heaven strawberry picking—and those children whose mothers had already eaten the fruit would not find any more strawberries left for them.

Folk-medicine and superstition attributed demonic powers to the small plants with their white flowers and red fruit. Whoever ate the first flowers would not catch a cold for the rest of the year.

In addition, tea made from strawberry leaves was said to be effective against magic and witchcraft. However, the berries were recommended as an antidote for anaemia and general weakness because of their high iron and phosphorus content. MH

left: strawberry plant from Versailles, 1787
right: Adriaan Coorte, *Still Life with Fruits and Asparagus*, 1703

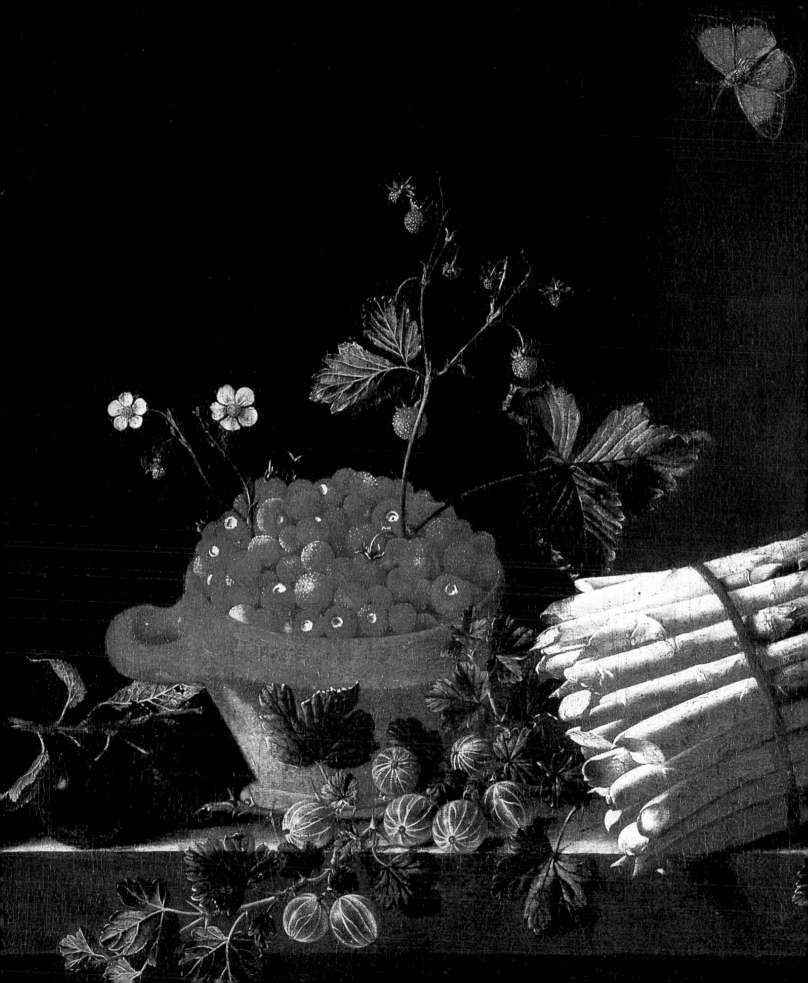

Sunflower

Helianthus annuus

Vital source of food, medicine and oil; natural vitality; loyalty; pride; devotion; inspiration to Van Gogh

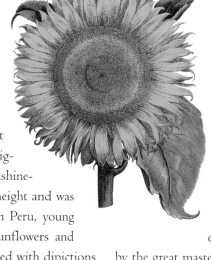

The sunflower is native to most of North America. Even in 3000 BC, the wild species was already being cultivated by Native American Indians. It was an important source of food and medicine as well as a pigment for body paint. This majestic, sunshine-yellow perennial can reach four metres in height and was regarded as sacred. At religious festivals in Peru, young women carried garlands or bunches of sunflowers and breastplates of pure gold were even fashioned with dipictions of the sunflower.

After the Spanish conquistadores arrived in the New World, the destruction of the indigenous cultures meant the loss of an ancient knowledge of the sunflower's significance and use. It was not until the last quarter of the nineteenth century that the plant returned to America with Russian emigrants who used it as a source of oil.

The sunflower arrived in Spain in 1569 and large expanses of the countryside were soon coloured yellow. It spread slowly across the rest of Europe, firstly as a decorative plant until the seventeenth century when sunflower seeds began to be baked in bread and roasted as a coffee substitute. The cultivation of sunflowers for oil, however, was almost unheard of in Europe until the beginning of the nineteenth century.

The sunflower takes its name from its shape and its heliotropism—its propensity to grow towards sunlight. Even as a growing plant, its head follows the course of the sun and the mature flower permanently faces east, towards the rising sun.

The sunflower was still absent from early seventeenth-century flower paintings by the great masters, but gradually it made its way onto canvass and came to symbolize the sovereign and his subjects' loyalty; it was a sign of pride. In Britain, it came to represent the dependence between the king and his people. In Christian iconography, the sunflower signified believers' devotion to the Catholic church. Like the flower that always grows towards the light—towards the divine sun—it represents the devout soul striving towards god. The sunflower's importance in art diminished during the eighteenth century. It was Vincent van Gogh who re-established its popularity a century later by using it as a motif in its own right. Like no other flower, the sunflower typifies natural vitality and an affinity with primitive nature. SW

left: flower and stamen of the sunflower, 1840
right: Jan Davidsz de Heem, *Fruit and Flower Cartouche with Wine Glass*, 1651

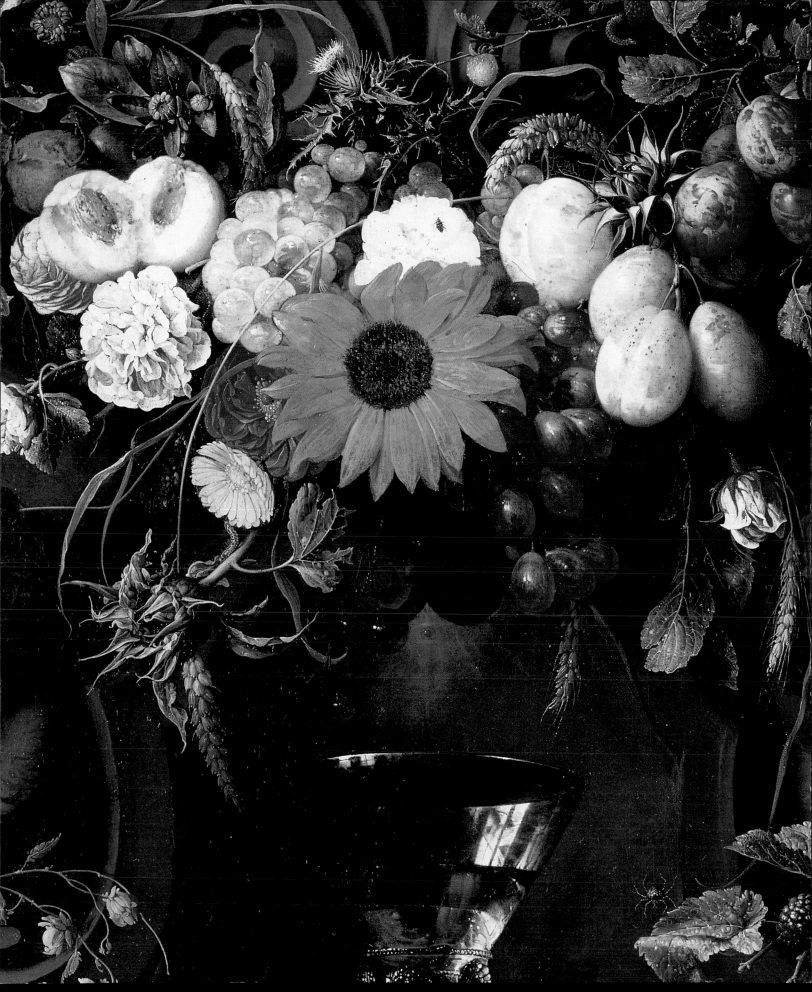

Thistle

Silybum marianum

Scotland's national emblem; a symbol of hard work, suffering and Christ's deliverance; dispels melancholy

The thistle is a large family of plants found throughout the world. Despite its coarse appearance, many of its leaves and flowers are unusually attractive when looked at more closely and the sweet fragrance of the thistle's flowers attracts bees and a varitey of birds. In Greek mythology, Aphrodite presented the youth Phaon with a thistle that can be seen as an allegory for being easily "ensnared" on the prickles. However, in fairy tales thistles sometimes symbolise an enduring love that, despite pain and suffering, continues to grow and grow. An ancient symbol, the thistle has figured in Scottish heraldry for over five hundred years, perhaps based on the apocryphal tale of an invading Viking who trod on a thistle, his anguished cry alerting the Scots to an attack. The Order of the Thistle was founded by James VII in 1687 and its motto *nemo me impune lacessit* may allude to this tale. Roughly translated it means "no one attacks me and gets away with it."

If they were unable to choose between different suitors, English girls in the nineteenth century consulted a "thistle oracle". The outermost shoots of a number of different thistles were cut off, each shoot given the name of an admirer and then placed under the pillow before retiring to bed. In the morning, the shoot that had started to bud during the night revealed the name of the man the girl should marry.

Carduus marianus

Dioscorides, an ancient Greek botanist, claimed that anyone in possession of the root of a thistle would be able to dispel melancholy. This belief persisted across the millennia and influenced Christian symbolism. "Thistle stock drunk in wine ought to dispel all unnecessary melancholy in a man and cause him to be merry."

The thistle does not hail from Eden; quite the opposite, in fact, as only after the Fall of Man and Adam and Eve's Expulsion from Paradise did God say unto Adam: "... accursed shall be the ground on your account. With labour you shall win your food from it all the days of your life. It will grow thorns and thistles for you," since which time thistles have been under a curse. In popular belief, they are a gift from the Devil himself, a plant that means trouble and hard work. Through its connection with the Fall of Man, the thistle is a reminder of the original sin and a symbol of deliverance through Christ's Passion.

Butterflies on thistles, however, are a sign of the Resurrection; once free of their chrysalises, they represent redeemed souls. 		MH

left: inflorescence and root of the milk thistle, 1828
right: Barbara R. Dietzsch, *Thistle with Insects*, n.d.

Tulip

Tulipa gesneriana

Object of wild speculation; a symbol of vanitas but also of spring; wealth and importance; arrogant and aloof

The tulip hails from Persia and first had its praises sung by Hafis (1327–90), the great Persian poet: "See these cheeky tulips, how they raise their coloured cups and demand to sup."

In its homeland, the tulip was a declaration of love. Like so many flowers, legend has it that it was created from a drop of blood: "Spring was yet young and the tulip had raised its red cup when Ferhad died from love of Schirin, colouring the desert red with his heart's tears."

The tulip grows upright and is regarded as a flower of the sun. It faces into the light and it closes its petals at dusk. It is not, however, a flower known for its mythological associations and it seems always to have been more disposed towards worldly matters. Even a short while after its introduction to Turkey, it commanded the highest prices. Eventually, Turkish sultans of the Osman dynasty chose the flower as their heraldic emblem. In the eighteenth century, Turkish adoration of the tulip reached an enthusiastic and lavish climax in the yearly tulip festivals that were held in the sultan's gardens. The loveliest varieties had names that matched the display of splendour laid on: "Dream of bliss", "Secret of the eternal" and "Elixir of love".

The flower made its way to Vienna in 1554 with Ghiselin de Busbeqc, the Austrian ambassador to the court of Süleyman and it was at this time that

the tulip acquired its name. The noble ambassador thought the Turkish name for the flower was "tülbend" when, in fact, he had misunderstood a reference to the Turks' red turban, to which the tulip was being compared on account of its shape and colour. In Turkey itself, however, the flower is known by its Persian name "lalé".

It was merchants and scholars who first imported the tulip to the Netherlands after 1593. Whole houses and ships full of cargo were exchanged for only a few bulbs and, as a sign of wealth, *tülbend* appeared in Rembrandt's famous floral still lifes. When the Dutch parliament fixed the price of tulips in 1637, the markets collapsed and many suffered financial ruin. It is hardly surprising, then, that the tulip came to be the main symbol of *vanitas*. Paintings of the seventeenth century often depict it alongside skulls. The tulip was often regarded as arrogant and vain, stiff and cool. And it is true that the scentless flower remained aloof: just as it lacks mythological associations, the tulip is no friend of poets who never took the flower to their heart. At least the lovely *lalé* found its way into the hearts of ordinary folk who came to associate it with spring and see in it a symbol of life after death. SW

left: flower and bulb of the wild tulip, 1809
right: Georg Flegel, *Two Tulips, c.* 1630

Violet

Viola odorata

Innocent love; humility, modesty but also ambitiousness; resurrection and spring; heraldic flower

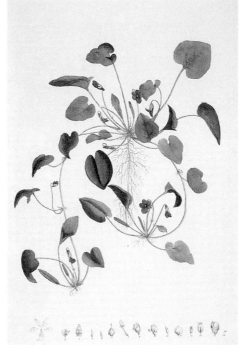

You almost have to get down on your hands and knees to glimpse the purple flowers of the fragrant violet beneath its green foliage. The great German poet and dramatist Goethe (1749–1832) had the violet declare: "I am hidden and stooped and shun conversation." Yet this well-loved spring flower has much to say. During the Middle Ages, it was regarded as a sign of humility and modesty. The flower represented both the humility of the Virgin Mary and her determination which in turn were equated with the rapid spread of Church doctrine. This interpretation was prompted by early observations which noted that hardly any other plant is so forceful and successful in its growth as the violet. After first flowering in March, small tendrils and shoots quickly start to form new growth around the mother plant. The attractive purple flowers are infertile and are not pollinated. In summer, it flowers once again in an unprepossessing manner with buds inclined towards the ground. It is self-pollinating, an unusual feature that was seen as wonderfully symbolic of the Virgin Mary's immaculate conception. Shakespeare saw in the violet a symbol of innocent love.

Violets have always been much sought-after. Ancient Athens was known as the "violet-wreathed" city because the guests of Athenians were presented with violet garlands. These were also hung on doors as a form of decoration and placed on statues of gods. Mohammed declared the violet a symbol of the power of his teachings, while in Persia, the flower was called the "rose's prophet", a herald of the still sweeter rose.

No convent garden did without its violets in the Middle Ages when the first flower to bloom was tied to a stick and a spring dance was held around it. In the gardens of the French Empress Josephine, the modest violet was grown in large numbers because she loved the flower more than any other. Napoleon came to share her passion. From his exile on Elba, he declared he would return accompanied by violets. When he entered Paris the following March, his supporters sported violets in their lapels. The flower later became the heraldic flower of Napoleon and his successors. The defeated emperor took violets from Josephine's grave with him to St Helena. Even in antiquity, violets were planted on graves because the fragrant flowers had a mythological connection with the hereafter. Persephone was strolling across a meadow of violets when Hades caught her and carried her off to the underworld. The violet thus became a symbol of the immortal soul and of resurrection and spring. MH

left: scented violet, 1828
right: Albrecht Dürer, *Bouquet of Violets*, 1501

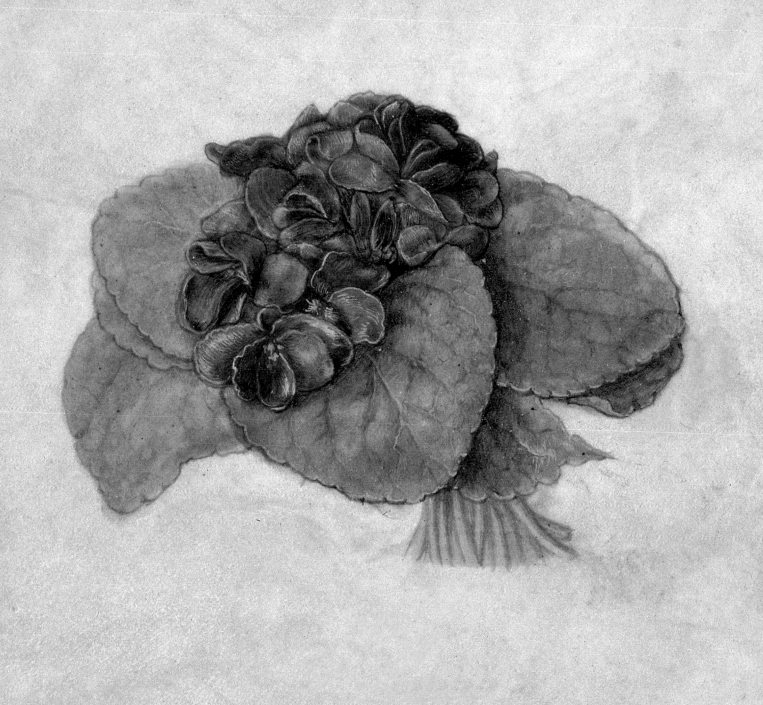

Anemone page 21
Jean-Michel Picart, *Flowers in a Carafe*,
c. 1650, oil on canvas, Musée d'Art
Moderne de Saint-Etienne

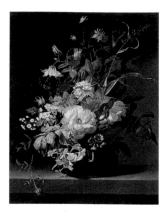

Aquilegia page 23
Rachel Ruysch, *Flowers in a Vase*,
early 18th century, oil on canvas,
The National Gallery, London

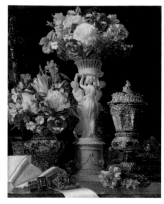

Camellia pages 2 and 25
Ferdinand Waldmüller, *Birthday Table*,
1840, oil on canvas,
Wallraf-Richartz-Museum, Cologne

Carnation page 27
Jacob Marrel, *Flower-adorned Cartouche with a
View of Frankfurt*, 1651, oil on wood,
Historisches Museum der Stadt Frankfurt
am Main

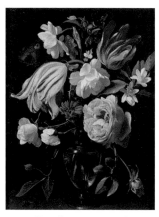

Cornflower page 29
Daniel Seghers, *Vase with Flowers*,
1637, copper, Staatsgalerie Bamberg
(Royal Residence), Bayerische Staatsgemälde-
sammlungen, Bamberg

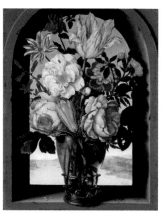

Crocus page 31
Ambrosius Bosschaert the Elder,
Bouquet of Flowers, 1620, oil on canvas,
Musée du Louvre, Paris

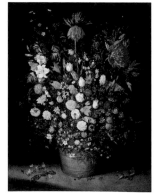

Crown Imperial page 33
Jan Breughel the Elder, *Bouquet of Flowers*,
after 1607, oil on oak wood, Alte Pinakothek,
Bayerische Staatsgemäldesammlungen, Munich

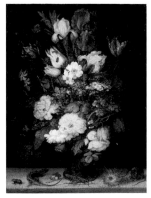

Daffodil page 35
Roelant Savery, *Bouquet of Flowers*, 1612,
oil on canvas, Collection of the Prince of
Liechtenstein, Vaduz

Daisy page 37
Bellis perennis, from *Curtis Botanical Magazine*,
no. 228, vol. 7, 1793,
Botanisches Museum, Berlin

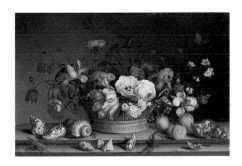

Forget-me-not page 39
Balthasar van der Ast, *Still Life with Basket of Flowers*,
1640/50, oil on canvas,
Statens Konstmuseer, Stockholm

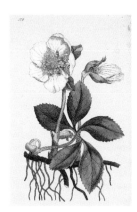

Hellebore page 41
Helleborus niger, from *Curtis Botanical Magazine*, vol. I, 1787,
Botanisches Museum, Berlin

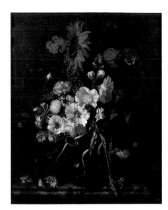

Honeysuckle page 43
Maria van Oosterwyck, *Flowers and Shells*,
1740, oil on canvas,
Gemäldegalerie Alter Meister, Dresden

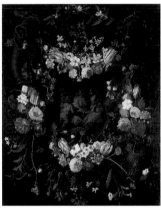

Hyacinth page 45
Daniel Seghers, *Flower Garland with Mary, Christ and St. John as a Boy*, c. 1645, oil on canvas, Gemäldegalerie, Staatliche Museen zu Berlin Preussischer Kulturbesitz, Berlin

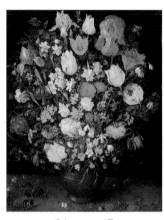

Iris page 47
Jan Breughel the Elder, *Small Bouquet of Flowers in Clay Vessel*, c. 1670, oil on canvas,
Kunsthistorisches Museum, Vienna

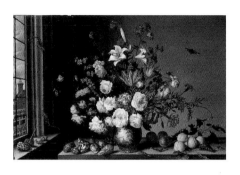

Lily page 49
Balthasar van der Ast, *Still Life with Flowers and Fruits*, c. 1640/50, oil on oak wood,
Anhaltinische Gemäldegalerie Dessau

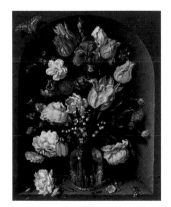

Lily of the Valley page 51
Jacques de Gheyn, *Flowers in a Glass*,
1612, oil on canvas,
Haags Historisch Museum, The Hague

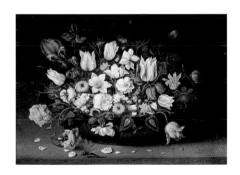

Love-in-a-mist page 53
Osias Beert, *Basket of Flowers*,
c. 1615, oil on wood,
Musée du Louvre, Paris

Mallow page 55
Rachel Ruysch, *A Vase of Flowers on a Plinth*,
1701, oil on canvas,
Fitzwilliam Museum, University of Cambridge

 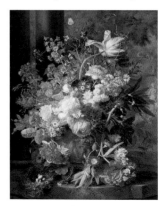

Marigold page 57
Ambrosius Bosschaert the Elder, *Flower Still Life*,
1614, oil on copper,
The J. Paul Getty Museum, Los Angeles

Myrtle page 59
Piero di Cosimo, *Venus, Mars and Amor*,
c. 1505, oil on poplar wood, Gemäldegalerie,
Staatliche Museen zu Berlin Preussischer
Kulturbesitz, Berlin

Oranges and Lemons page 61
Francisco de Zurbáran, *Still Life with Lemons,
Oranges and a Rose*,
1633, oil on canvas,
The Norton Simon Museum, Pasadena

 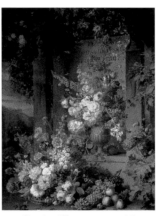 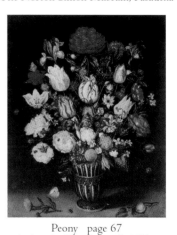

Pansy page 63
Henri Fantin-Latour, *Still Life with Pansies*,
1874, oil on canvas, The Metropolitan Museum
of Art, New York, Mr. and Mrs. Henry Ittle-
son, Jr. Purchase Fund, 1966.66.194

Passion Flower page 65
Jan Frans van Dael, *Tomb of Julie*,
1803/04, oil on canvas,
Chateaux de Malmaison et Bois-Préau,
Malmaison

Peony page 67
Ambrosius Bosschaert the Elder,
Bouquet of Flowers,
c. 1610, oil on canvas, Alte Pinakothek,
Bayerische Staatsgemäldesammlungen, Munich

 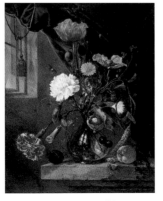 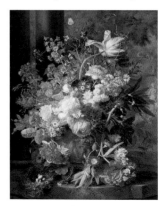

Pomegranate page 69
Jan Davidsz de Heem, *Fruit and Flower Cartouche
with Wine Glass*, 1651, oil on canvas, Gemälde-
galerie, Staatliche Museen zu Berlin
Preussischer Kulturbesitz, Berlin

Poppy page 71
Jan Davidsz de Heem, *Bouquet of Flowers in a
Glass Vase*, *c.* 1640, oil on canvas,
Gemäldegalerie, Staatliche Museen zu Berlin
Preussischer Kulturbesitz, Berlin

Primula page 73
Jan van Huysum, *Bouquet of Flowers in front
of a Park Landscape*,
c. 1730, oil on canvas,
Kunsthistorisches Museum, Vienna

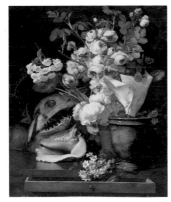

Rose page 75
Antoine Berjon, *Still Life with Flowers, Shells,*
a Shark Head and Fossils, 1819, oil on canvas,
Philadelphia Museum of Art
Purchased with the Edith H. Bell Fund

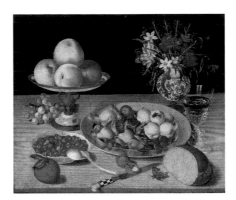

Rosemary page 77
Isaak Soreau (?), *Still Life with Flowers, Fruits,*
Wine Glass and Vase of Flowers,
c. 1620, oil on canvas,
Kunsthistorisches Museum, Vienna

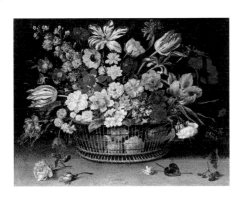

Stock page 79
Jacques Linard, *Bouquet of Flowers,*
early 17th century, oil on canvas,
Musée du Louvre, Paris

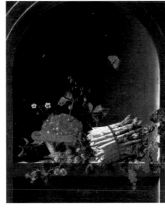

Strawberry page 81
Adriaan Coorte, *Still Life with Fruits and*
Asparagus, 1703, oil on canvas,
Koninklijk Museum voor schoone Kunsten,
Antwerp

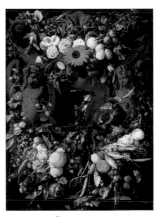

Sunflower page 83
Jan Davidsz de Heem, *Fruit and Flower Cartouche*
with Wine Glass, 1651, oil on canvas,
Gemäldegalerie, Staatliche Museen zu Berlin
Preussischer Kulturbesitz, Berlin

Thistle page 85
Barbara R. Dietzsch, *Thistle with Insects,*
n.d., Kupferstichkabinett, Staatliche
Museen zu Berlin Preussischer
Kulturbesitz, Berlin

Tulip page 87
Georg Flegel, *Two Tulips,*
c. 1630, watercolour, Kupferstichkabinett,
Staatliche Museen zu Berlin Preussischer
Kulturbesitz, Berlin

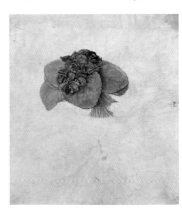

Violet page 89
Albrecht Dürer, *Bouquet of Violets,*
1501, watercolour, Albertina, Vienna

Index of Flowers and their Meanings

Numbers refer to pages

· 94 ·

Photographic Credits

Anders, Jörg P., Berlin: pp. 12, 14 bottom, 16 top, 45, 59, 71, 81, 83, 85, 87, 91, 92, 93

Cussac, G., Brussels: p. 19

Heilmeyer, Marina, Berlin: pp. 41, 91

Klut/Estel, Dresden: p. 14 top

Thiem, Eberhard (Lotusfilm), Kaufbeuren: p. 8

Wood, Graydon: pp. 75, 93

Ziegenfusz, Horst: pp. 27, 90

Antwerp, Koninklijk Museum voor schone Kunsten: pp. 69, 92

Berlin, Bildarchiv Preussischer Kulturbesitz: p. 10

Berlin, Botanischer Garten and Botanisches Museum: pp. 37, 90

Cambridge, Fitzwilliam Museum, University of Cambridge: pp. 55, 91

Cologne, Rheinisches Bildarchiv: pp. 2, 25, 90

Dessau, Anhaltinische Gemäldegalerie Dessau: pp. 49, 91

Dresden, Gemäldegalerie Alte Meister: pp. 43, 91

The Hague, Haags Historisch Museum: pp. 51, 91

London, National Gallery: pp. 23, 90

Los Angeles, The J. Paul Getty Museum: pp. 57, 92

New York, The Metropolitan Museum of Art: pp. 63, 92

Paris, Musée des Arts Decoratifs: p. 15 (E. Sully-Jaulmer)

Paris, Réunion des Musées Nationaux: p. 16 bottom (G. Blot); pp. 53, 91 (G. Blot/C. Jean); pp. 31, 90 (C. Jean); pp. 79, 93; pp. 65, 92 (Arnaudet, J. Scho)

Pasadena, The Norton Simon Foundation: pp. 61, 92

Peissenberg, Artothek: p. 18 bottom, pp. 33, 90 (Joachim Blauel); pp. 29, 90 (U. Zimmermann)

Rome/Scala, Museo delle Terme: p. 9

Saint-Etienne, Musée d'Art moderne de Saint-Etienne: pp. 21, 90

Stockholm, The National Museum of Fine Art: pp. 39, 91

Vaduz, Collection of the Prince of Liechtenstein, Vaduz Castle: pp. 35, 90

Vienna, Albertina: pp. 89, 93

Vienna, Kunsthistorisches Museum: pp. 47, 73, 77, 91, 92, 93

Vienna, Österreichische Nationalbibliothek: p. 11

The botanical illustrations have been taken from the following works:

p. 30: Anckelmann, Caspar, *Blumenbuch* (Horti Anckelmanniani I.), Norddeutsche Schule, *c.* 1700, 191 painted sheets without text; Kupferstichkabinett. Staatliche Museen zu Berlin Preussischer Kulturbesitz

p. 78: Besler, Basilius, *Hortus Eystettensis*, Nuremberg 1613

pp. 20, 24, 28, 32, 34, 56, 80, 86: *Curtis Botanical Magazine*, 1787–1839. In 1787 the pharmacist William Curtis (1746–99) founded the *Botanical Magazine*, which Samuel Curtis continued after his death. Until 1799 the illustrations were drawn by Sowerby and Kilburn. Botanischer Garten and Botanisches Museum Berlin-Dahlem, FU Berlin

pp. 22, 26, 38, 42, 52, 58, 72, 76, 82: Schlechtendal, Diedrich Franz Leonhard von, *Flora von Deutschland*, Jena 1840–73, with drawings by Ernst Schenk. Botanischer Garten and Botanisches Museum Berlin-Dahlem, FU Berlin

pp. 44, 48: Reichenbach, Heinrich Gottlieb Ludwig, *Deutschlands Flora*, 1837–50. The drawings are also by the author. Botanischer Garten and Botanisches Museum Berlin-Dahlem, FU Berlin

p. 50: Dietrichs, Ludwig Michael, *Flora des Königreichs Preußen*. Botanischer Garten and Botanisches Museum Berlin-Dahlem, FU Berlin

pp. 40, 46, 54, 62, 66, 68, 70, 74, 84, 88: Nees von Esenbeck, Theodor Friedrich Ludwig, *Plantae officinalis oder Sammlung offizineller Pflanzen*, with lithographs by Aimé Henry, Düsseldorf 1821–28. Botanischer Garten and Botanisches Museum Berlin-Dahlem, FU Berlin

p. 36: Rousseau, Jean-Jacques, *La Botanique*, illustrated by Pierre-Joseph Redouté, 1805

p. 60: Risso, Antoine/Poiteau, Antoine, *Histoire Naturelle des Orangers*, Paris 1818–20. Orto Botanico del Universitá di Napoli, Italy

Special thanks to Dr. Dietrich Roth, Hamburg, for providing the illustrations on pp. 20, 30 and 66.